IMAGES
of America

DARIEN AND
McINTOSH COUNTY

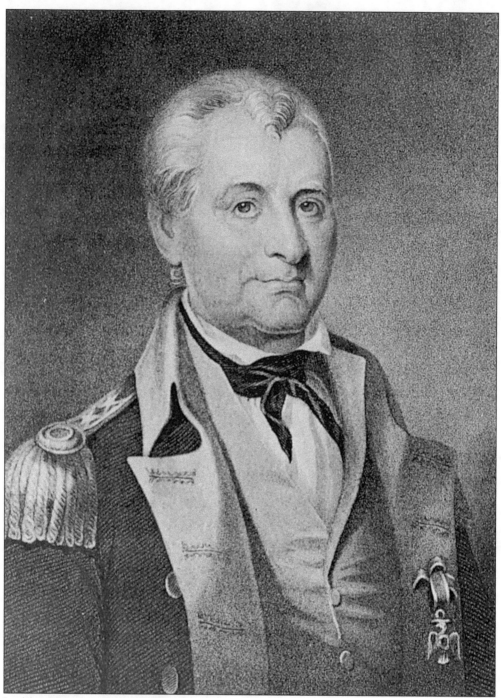

Lachlan McIntosh (1727–1806) was a prominent figure in the fight for America's independence. He served under George Washington and commanded the patriot forces of Georgia. He was nine years old in 1736, only three years after the founding of the Georgia colony, when his father, John Mohr McIntosh, led a group of Scottish Highlanders to settle the town they called Darien. Lachlan McIntosh, for which the county was named when it was created from Liberty County in 1793, was the most famous of the McIntosh family.

IMAGES
of America

DARIEN AND MCINTOSH COUNTY

Buddy Sullivan

ARCADIA
PUBLISHING

Published by Arcadia Publishing
Charleston, South Carolina

Library of Congress Catalog Card Number: 00-105325

For all general information contact Arcadia Publishing at:
Telephone 843-853-2070
Fax 843-853-0044
E-Mail sales@arcadiapublishing.com
For customer service and orders:
Toll-Free 1-888-313-2665

Visit us on the Internet at www.arcadiapublishing.com

CONTENTS

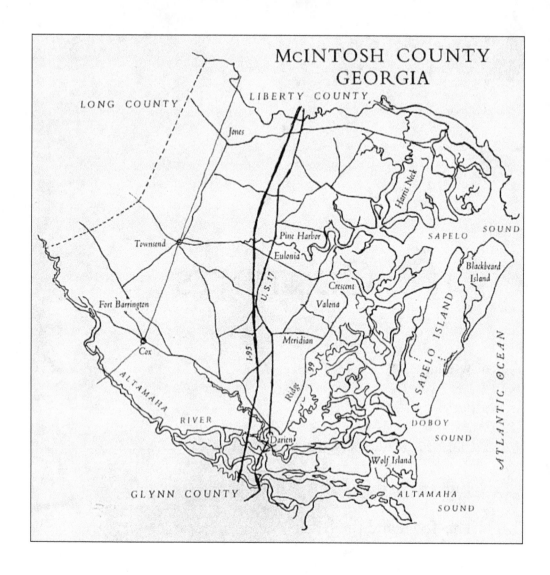

ACKNOWLEDGMENTS

This volume is a natural extension to my earlier works on the history of McIntosh County and coastal Georgia. What makes this book different is that many of the photographs utilized herein are not included in my earlier books, and a number are being published for the first time in book form.

Several individuals have been of great assistance to me by providing photographs, including David Bluestein, mayor of Darien, drawing from his outstanding collection of Darien postcards and photographs; Minnie Lee Rountree, from her collection of original pictures, some going back over 100 years; and the McIntosh County Development Authority, for prints of the rare 1874 stereoscopic views of a Darien rebuilt from the ashes of the Civil War. Several of these unique 1874 prints were originally published for the first time in the initial edition (1991) of my book *Early Days on the Georgia Tidewater, The Story of McIntosh County and Sapelo*.

INTRODUCTION

Darien, GA, was a deserted, undefended, little cotton port when federal forces sacked and burned the town on a warm summer afternoon in June 1863. The county seat of McIntosh County had only about 500 inhabitants before the Civil War. When the remnants of the town's population returned in April 1865 they were greeted by the ravages of the war.

There was good reason to hope for revival, based largely on the huge demand for Georgia yellow-pine timber in the north and overseas. Darien was ideally situated at the mouth of a great river system, the Altamaha, a natural conduit for timber from the upcountry. Although never the beneficiary of an ideal harbor, Darien nonetheless enjoyed a proximity to the sea that facilitated the export of its timber. The little town immediately began rebuilding after the war. Sawmills were constructed at Lower Bluff, Doboy, and Union Island. Pine timber began to be rafted down the Altamaha from the inland counties. The big lumber companies, such as Hilton & Dodge, Hunter & Benn, and James K. Clarke, bought the yellow pine for processing.

Ships along the East Coast (particularly from New England,) from South American, and from European ports came to McIntosh County waters to load timber and lumber. At Darien the rafts of timber often completely covered the river in the various branches of the lower Altamaha. It was said that a person could walk for miles upon the timber rafts assembled in the river and never get his feet wet. Ships would crowd the local harbors of Sapelo Sound and Doboy Sound, with as many as 87 vessels being counted in port at one time to load Darien lumber. Towboats, or steam tugs, towed drifts of timber and lumber out to the sounds for the larger vessels, while smaller ships sailed right into Darien to load at the Hilton-Dodge Lower Bluff Mill and other wharves along the waterfront. Until about 1895 these were primarily three and four-masted sailing vessels, especially designed for accommodating large loads of lumber. Many of these vessels arrived from overseas and deposited ballast rock in the local salt marshes in exchange for the output from Darien's sawmills. Later, larger steamships frequented the McIntosh timber port to take on lumber cargoes.

This timber "boom" period lasted for more than 50 years, from 1866 until the time of World War I. The peak year for timber activity in McIntosh County was 1900, when 112.6 million linear board feet of lumber was shipped. Darien was the Atlantic coast leader in lumber exports for a number of years in the late 19th century. After 1900, shipments began a steady decline due to the rapidly dwindling supply of timber in the upcountry. Timber along the Altamaha had been overcut and it was no longer feasible to build rafts and float them downriver to the Darien

mills. A severe hurricane in 1898 proved especially damaging to the local industry as mills were flooded and lumber rafts scattered far and wide.

In February 1890, the Darien Short Line Railroad began limited operations in McIntosh County, the plan by local investors being to expedite the shipment of timber from the interior to the shipping points at Sapelo Sound and the big sawmills at Darien. Track was laid through the county, finally reaching Darien in early 1895. The Darien & Western Railroad gave way to the Georgia Coast & Piedmont, which operated until 1920, when it went into receivership. The railroad, while a colorful chapter in local history, had come too late to save the McIntosh timber port, and after 1910, the industry fell on hard times.

Just as timber had proven to be the county's economic salvation following the demise of local rice production, so the commercial harvest of shellfish came to the fore when the river timber industry began to wither. After 1900, McIntosh County experienced a rapid growth in oyster production. Coastal Georgia was one of the most fertile areas in the United States for oyster harvests and much of the production occurred in McIntosh County. Still later, in the 1930s, the commercial harvest of shrimp rose to prominence in the area. By the 1950s and 1960s, the McIntosh County shrimp fleet was one of the largest on the Atlantic coast.

This volume of pictures also touches on other little-known aspects of McIntosh County, particularly those isolated sections of the remote western portion of the county "off the beaten track." Areas covered in this regard are Eulonia, Townsend, and Darien Junction, sections once dominated by intensive timbering and turpentining activity.

This pictorial history examines the impact of waterways and watermen upon Darien and McIntosh County. The alluvial Altamaha River and its natural tendencies were described in 1874 by local newspaper editor Richard Grubb as being characteristic of the Nile. Towboats, transporting drifts of timber to ships in the local sounds, and oystermen and shrimpers of the early to mid-20th century can be seen making their living amid the tidal mudflats, salt marshes, and shallow estuaries of the near shore.

This book explores, through text and archival photographs, the most dynamic period in the history of Darien and McIntosh County. The peaks and valleys of the community's economic fortunes, from timber to railroads to commercial fishery, are documented through the following series of visual images. Fortunately, both Darien and McIntosh County have a rich visual legacy that has survived over the years to record their abundance of history and tradition. The pictures that follow serve as a lasting testimony to a time long ago, when a small Georgia tidewater county, through agriculture, timber, commercial fisheries, and its naval stores industry, flexed some of the most powerful economic muscles on the south Atlantic seaboard.

Those wishing to read a fuller examination and source documentation of these and other events associated with this period of Darien and McIntosh County's history should consult the author's *Early Days on the Georgia Tidewater, The Story of McIntosh County and Sapelo*, 5th edition, published in 1997.

One

OUT OF THE ASHES
OF THE CIVIL WAR

Rice production in the Altamaha delta, started by McIntosh County and Glynn County planters, made the region one of the wealthiest sections of Georgia during the antebellum era. The port of Darien grew increasingly active through the shipment of rice and upland cotton to Savannah, Charleston, and northern outlets. This map (c. 1840) depicts an area of the Altamaha just south of Darien. Tunno's (Champneys) Island rice fields are shown, with Elizafield rice plantation across the river. The leading cultivators of rice in McIntosh in the 1840s and 1850s were Pierce and John Butler (Butler's Island,) Jacob Barrett (Champneys,) Thomas Forman (Broughton,) P.M. Nightingale (Cambers,) D.M. Dunwody (Sidon,) and R.L. Morris (Ceylon and Potosi.) In Glynn, the main planters were James Hamilton Couper (Hopeton and Altama,) Hugh Fraser Grant (Elizafield and Evelyn,) and James Troup and George C. Dent (Hofwyl-Broadfield.)

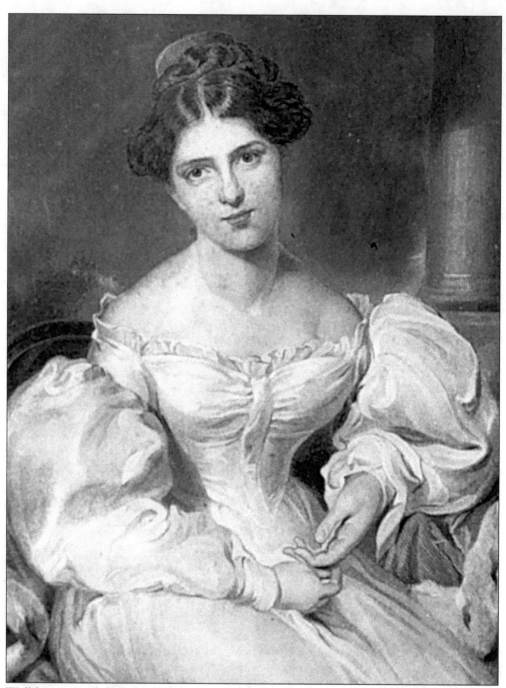

Well-known English actress Frances Ann Kemble married Pierce Mease Butler of Philadelphia in 1834, the latter having inherited his grandfather's rice plantation near Darien. In the winter of 1838–39 Fanny Butler accompanied her husband on an inspection tour of his Georgia plantations. What resulted from her four-month stay was the controversial *Journal of a Residence on a Georgian Plantation*, published in America in 1863 during the height of the Civil War. The Kemble journal was an indictment of slavery in the severest terms and has been the subject of much scrutiny by scholars.

The Bank of Darien was reportedly the most powerful financial institution in the southern states for a period of time in the 1820s and 1830s. Built on Darien's lucrative trade in the export of rice and upland cotton, the Bank had Georgia branches in Savannah, Augusta, Milledgeville, and Dahlonega, where it helped finance the north Georgia gold fields.

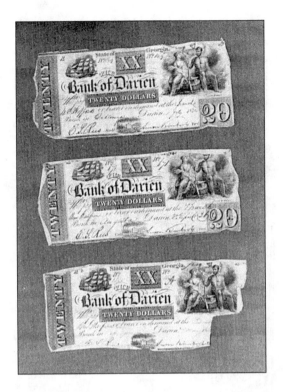

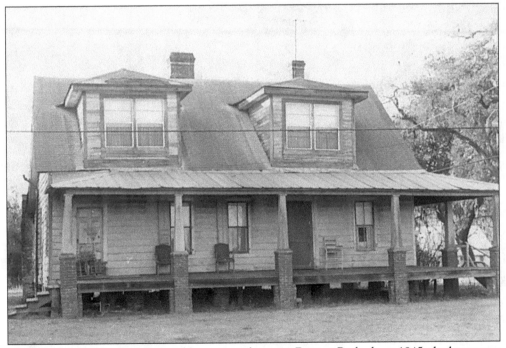

This wood-frame dwelling is the oldest private home in Darien. Built about 1845, the house was the residence of Woodford Mabry (port collector for Darien and Brunswick in the 1850s and early 1860s.) This was one of the only structures to be spared the torch when Darien was burned by Federal troops in June 1863.

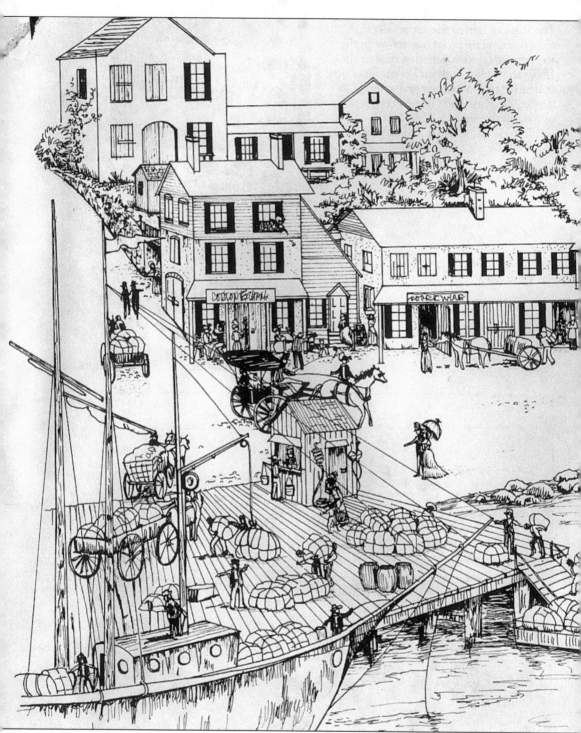

This is how Darien's waterfront district would likely have appeared on the eve of the Civil War in 1860. There were buildings on the upper bluff, separated from those on the immediate riverfront by an alleyway (very similar to Savannah's famous Factor's Walk.) Darien did a lucrative business in the export of cotton and rice. Several factorage houses were on the

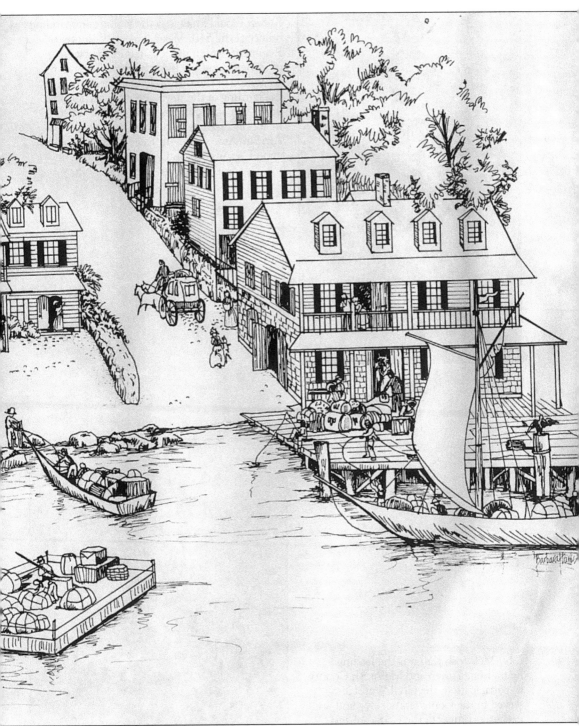

riverfront, as well as the local cotton exchange. These structures were all burned during the 1863 Union raid on Darien. However, the tabby foundations of these structures remain as testimony to the golden era of Darien's prominence as a seaport.

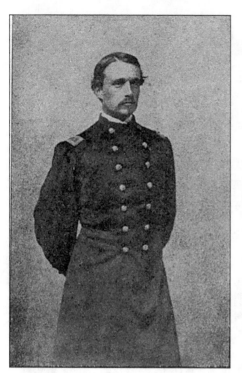

Robert Gould Shaw was the young commanding officer of the 54th Massachusetts Volunteer Regiment, which participated in the burning of Darien, June 11, 1863. Shaw, as second in command of the raid on Darien, protested the burning of the town and only participated under threat of court martial. He was killed in action a month later while leading his African-American 54th Regiment in the assault upon Fort Wagner in Charleston harbor, an incident featured in the 1990 movie *Glory*.

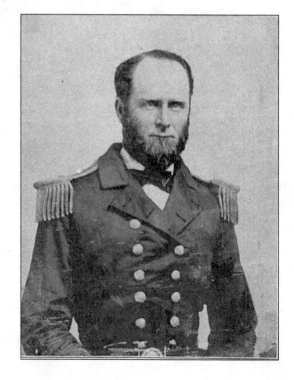

John McIntosh Kell was the leading figure from Darien and McIntosh County to participate in the Civil War. He served in the Confederate Navy and was executive officer of the CSS *Alabama*, the most famous Confederate warship in the war. The *Alabama*, during a two-year around-the-world cruise, sank over 60 Union merchant vessels.

St. Cyprian's Episcopal Church of Darien was built of tabby in 1876 by the former slaves of the Butler's Island rice plantation. They were assisted in their effort by Rev. James Wentworth Leigh, an Anglican clergyman who had married Frances Butler, daughter of Pierce and Fanny Kemble Butler.

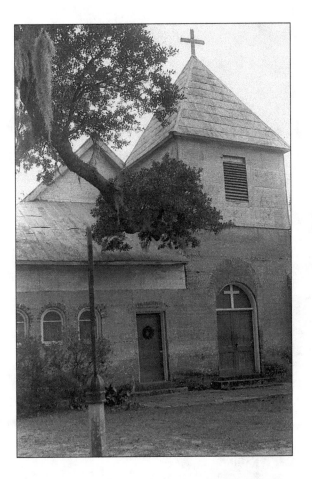

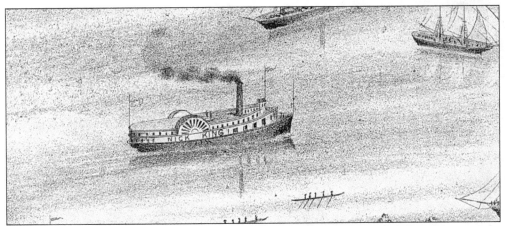

Steamboat traffic along the inland waterway of the Georgia coast provided the primary means of transportation for people, farm goods, freight, and mail during the period between 1865 and 1895, before a proliferation of railroads began to predominate. Single-stack steamers, such as the *Nick King*, ran between Savannah, Jacksonville, and the upper St. John's River during the 1870s and 1880s. Stops were made weekly in McIntosh County at Sapelo High Point, Doboy Island, Union Island, and Darien.

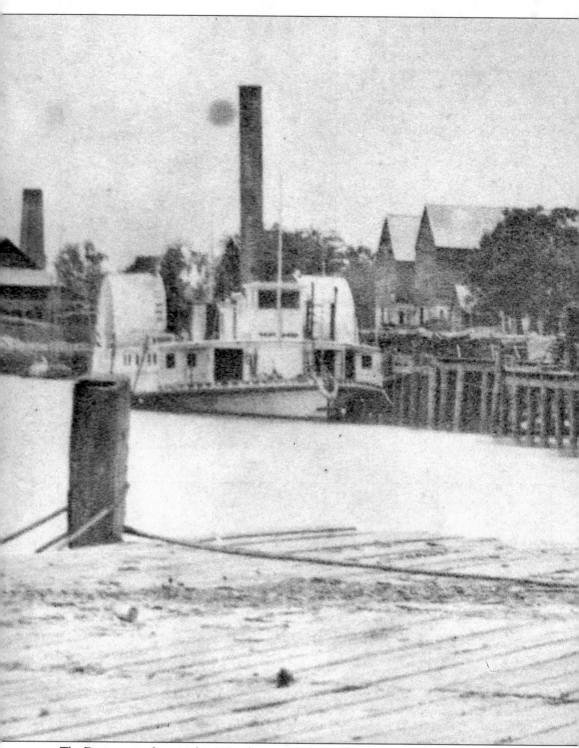

The Darien waterfront in this 1874 photograph shows a bustling tidewater town that has rapidly recovered from the ravages of the Civil War. A steamboat is shown docked at the wharf of the Magnolia Hotel, the imposing three-story structure at the right. The ruins at the extreme

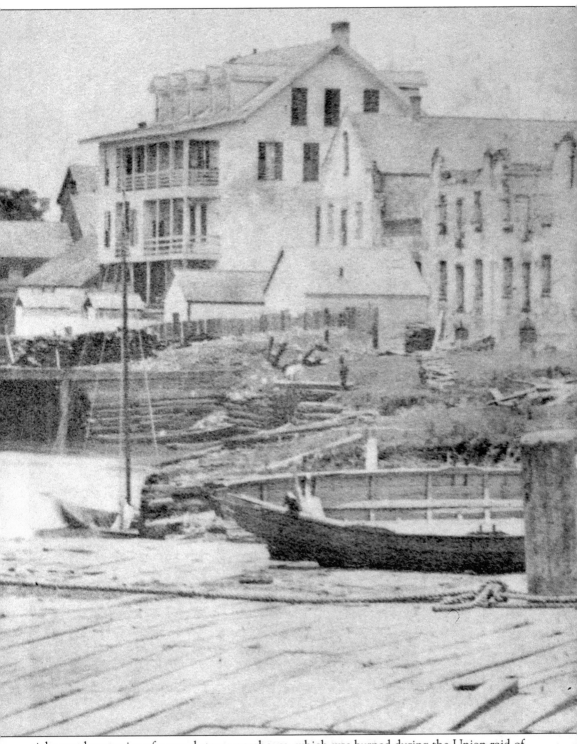

right are the remains of a naval stores warehouse, which was burned during the Union raid of 1863. In 1874, Darien was shipping over 20 million feet of lumber annually, a figure that would gradually rise until it peaked in 1900.

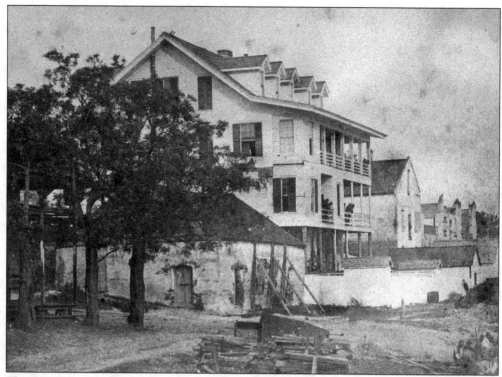

The Magnolia House was Darien's hotel and restaurant. This 1874 photograph depicts the structure about a year after its construction on the waterfront's half-bluff, on the site of the present Welcome Center. The middle level of the three-story building opened on Broad Street. The Magnolia House was the preferred place to stay for timber buyers who frequented Darien in the 1870s and 1880s. It burned in 1887 and was never rebuilt.

Northway Street, shown in the middle of this 1874 view, led to the river front. A portion of the ruins of the building at left are still standing. The building is located on the upper bluff front of Broad Street.

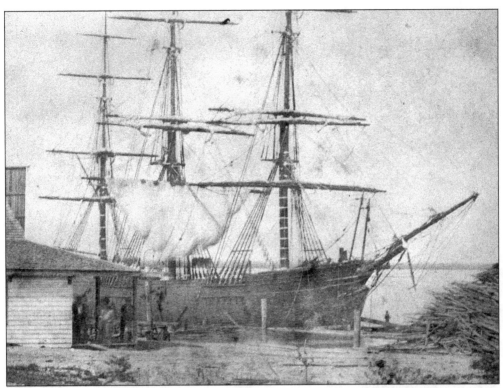

A sailing ship is shown loading timber through its bows at Doboy Island in 1874. Doboy had a sawmill and housing for African-American lumbermen and stevedores during the 1870s and 1880s.

This 1874 view from Doboy Island looks across the North (Ridge) River toward the timber ships docked at Rock Island. The tidal river shown is part of the inland waterway and flows into Doboy Sound a short distance to the right of this picture.

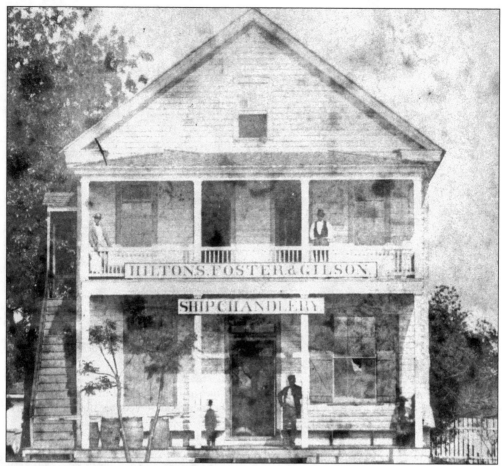

Joseph Hilton and his cousin, James Lachlison, were in the forefront of timber and lumber operations in Darien. By 1878, they had acquired the large Lower Bluff sawmill east of Darien. They also owned sawmills at Cathead (Upper Mill), Union Island, and Doboy Island. The store at Doboy (*c.* 1875) is shown in this view.

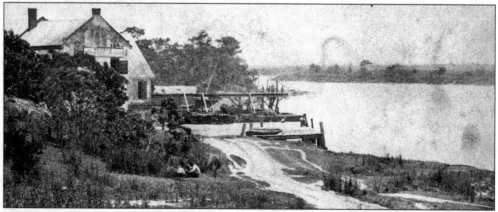

The Atlantic Sawmill of Darien was located on the later site of the Ploeger Seafood docks. In the distance to the right is the entrance to Generals Cut, which linked the Darien River with the Butler River. It had been dug by slave labor in the early 1800s.

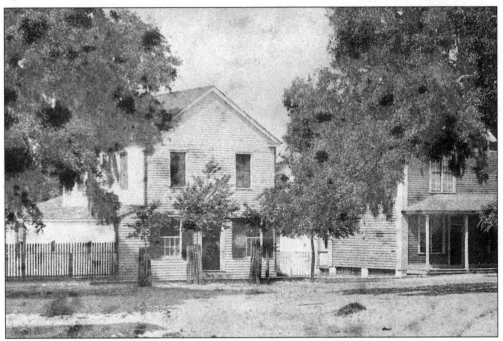

These wooden buildings were built on the upper bluff in Darien after the Civil War. They front Broad Street, with the rear of the buildings facing the river. The Magnolia House Hotel is just out of the right side of this 1874 photograph.

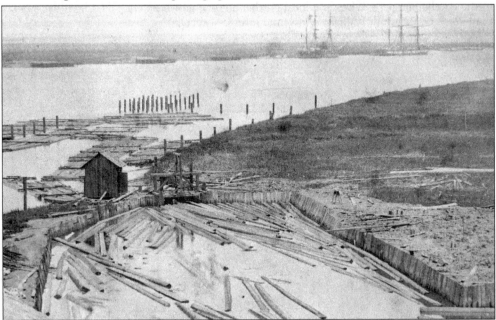

Squared logs of yellow pine are shown gathered at Doboy, with Rock Island in the background. By the middle 1870s, when this photograph was taken, Darien had become the leading pine-timber market on the south Atlantic coast. Increasing amounts of timber were being rafted from the upcountry down the Altamaha River to the sawmills in and around Darien and St. Simons Island.

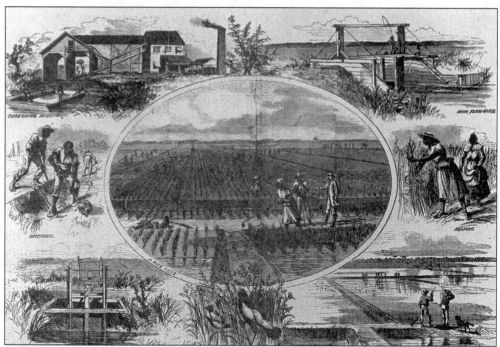

About a dozen McIntosh County rice planters resumed cultivation after the Civil War. Freed slaves worked in the rice fields for wages or for subsistence in the years immediately following the war. Rice prospered locally until about 1900, but not nearly on the scale as it had done in the antebellum period. Leading local postbellum rice growers were T.H. Gignilliat, C.O.S. Mallard, A.S. Barnwell, William Wylly, and John G. Legare.

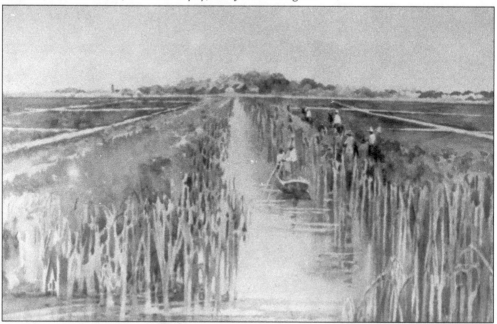

Postbellum rice plantations in McIntosh County were clustered in the Altamaha delta, located south of Darien and west of town along Cathead Creek. The same irrigation canals and embankments were used as those before the Civil War.

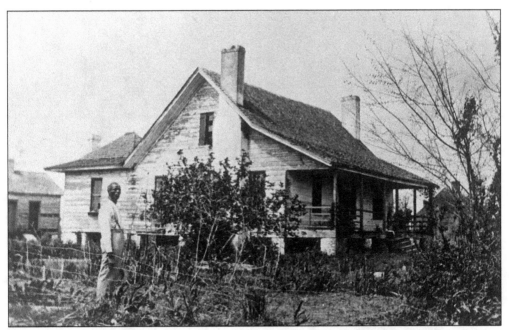

The overseer's house on Butler's Island near Darien was used as a part-time residence by Frances Butler Leigh and her husband, James Wentworth Leigh, during the years they planted rice (1867–1877). Rice cultivation proved unprofitable and labor relations with the former slaves were difficult to resolve. The Leighs eventually moved to England.

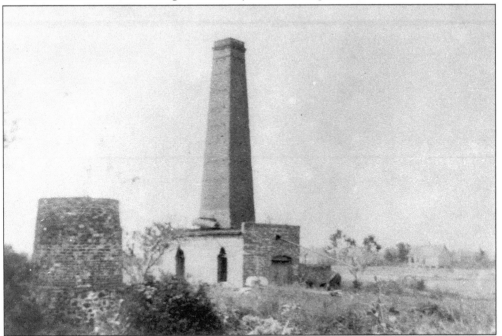

Shown in this photo (*c.* 1915) is the brick-rice-mill chimney at Butler's Island. The other brick structures are the remains of the steam-rice mill and the tidal-powered mill. These structures were built before the Civil War and facilitated the pounding and preparing of rice for shipment to market.

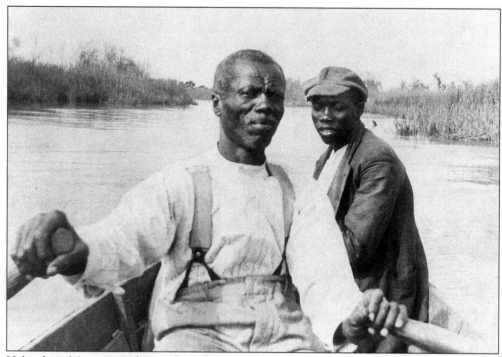

Habersham Mongin was born a Butler's Island slave. Here he is shown rowing a boat through Generals Cut between Butler's Island and Darien in 1915.

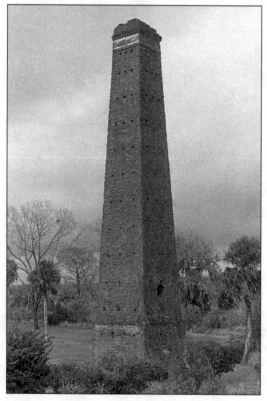

This is a modern-day picture of the Butler's Island rice mill chimney. For comparison, see the photo (*c.* 1915) on the previous page. Butler rice operations ended in 1877, later the island was leased to various other planters. Frances Butler Leigh leased the island to William H. Strain in 1901 and sold the island to the Strain family in 1906.

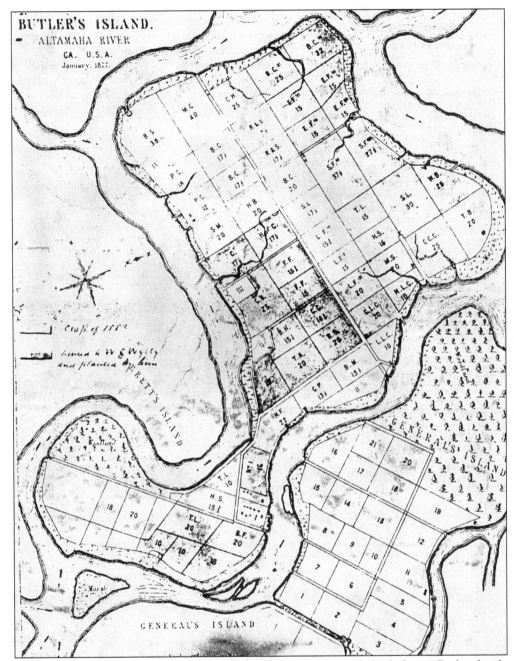

In January 1877 Butler's and Generals Islands were resurveyed, both being Butler family properties. This map delineates the system of rice squares for planting, irrigation ditches, canals, and the location of tidegates to regulate the inflow and outflow of fresh water into the fields from upriver. The tides facilitated the flooding and drainage of the fields.

The *Darien Timber Gazette*, the local weekly newspaper, kept buyers, raftsmen, and sawmill owners apprised of the local timber market, as determined by public timber inspectors appointed by the city government. The *Timber Gazette*, edited from 1874 to 1918 by Richard Grubb, also ran weekly port arrivals and departures of timber ships.

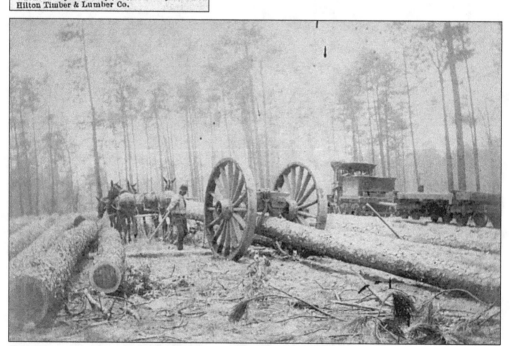

Yellow pine timber was cut in southeast Georgia forests by farmers and cutters in such areas as Montgomery, Laurens, Pulaski, Dodge, Telfair, Appling, and Tattnall Counties. Rafts of timber were floated down the Altamaha River to the "booms" at Darien.

Two

TIMBER AND THE
MIGHTY ALTAMAHA

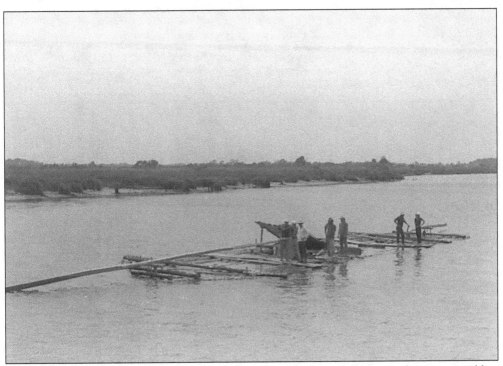

Crews of four to six men rafted pine timber down the Altamaha to Darien, where it was sold to the sawmills. From 1866 to about 1920 timber rafting was a way of life on the Altamaha River and its feeder rivers, the Ohoopee, Oconee, and Ocmulgee. This was the largest river system in the eastern half of Georgia.

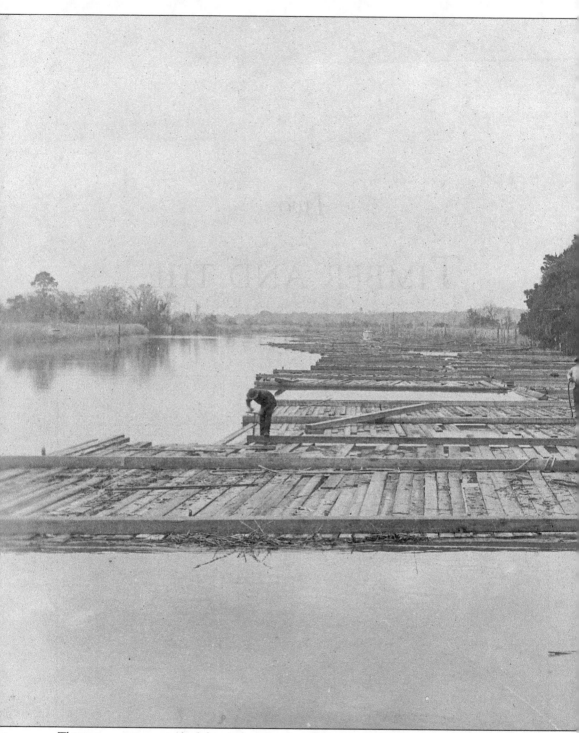

This was a scene typical of the timber era around Darien during the late 19th and early 20th centuries. Timber rafted down the Altamaha River was gathered in the tidal rivers around Darien in booms. Most of the timber had been "squared" before being rafted down to Darien. Shown on the gathered rafts are the Darien timber inspectors. These men measured, graded,

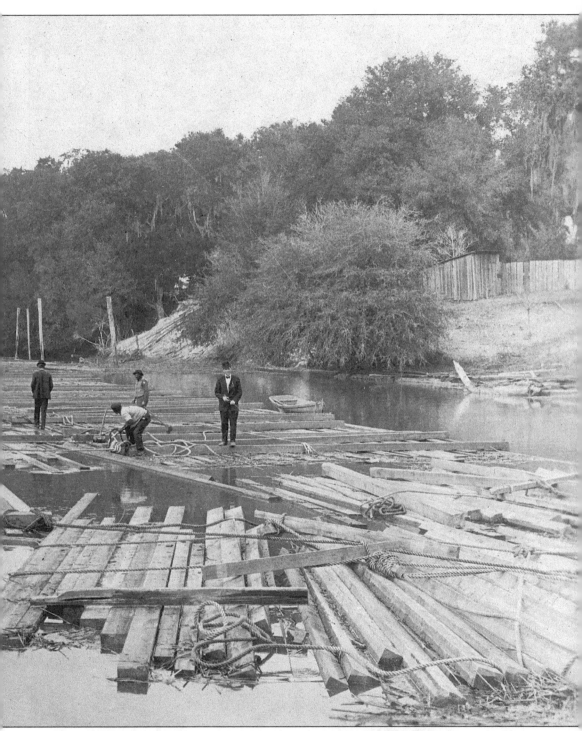

and set the local timber market prices. The Altamaha raftsmen sold their timber to the area sawmills and were not always in agreement with the prices set by the timber graders. This picture was made at Darien's Upper Sawmill on Cathead Creek around 1895.

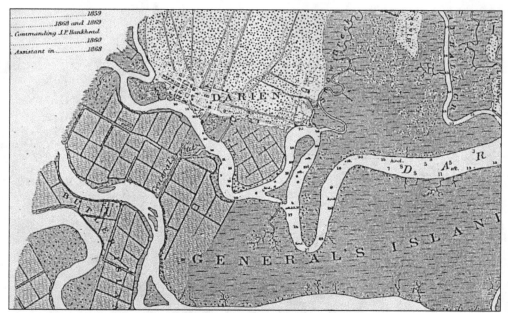

Near Darien, the Altamaha split into several branches. This 1871 chart shows the rice fields near Darien. Also shown is the serpentine Darien River (the north branch of the Altamaha). Darien's approaches had always been difficult to navigate, containing numerous shoals, sandbars, and tidal mudflats. The larger ships remained in the deeper anchorage at Doboy or Sapelo. Timber and lumber was rafted out to these large vessels by towboats.

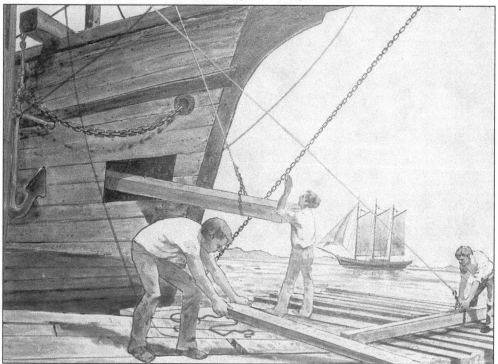

Squared timber was loaded through the bow ports of the sailing ships that frequented the waters around McIntosh County in the last three decades of the 19th century.

30

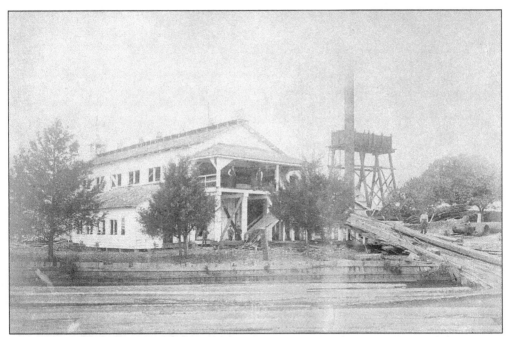

The Lower Bluff sawmill, one mile east of Darien, was acquired by the firm of Hiltons & Foster in 1878. Ten years later, Joseph Hilton merged his interests with the Dodge family's operations at St. Simons Mills to create the Hilton-Dodge Lumber Company, the largest pine-timber concern on the Atlantic seaboard.

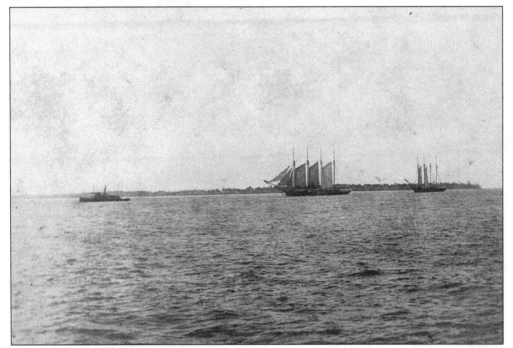

A four-masted timber ship is brought into Doboy Sound, led by a steam-powered towboat in this photograph (c. 1885.) The south end of Sapelo Island and the open Atlantic Ocean are in the background.

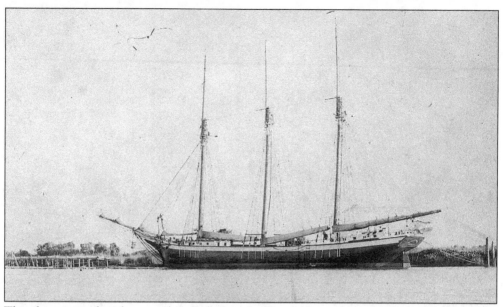

This three-masted timber vessel is docked in the Darien River near the Lower Bluff sawmill. The lower Altamaha River was crowded with shipping and timber rafts during the "season," which generally ran from September to May.

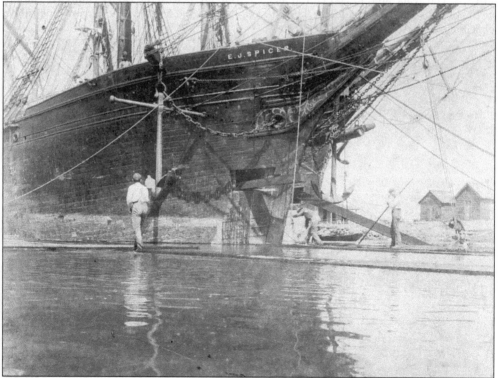

The *E.J. Spicer* is loading squared beams of pine timber through its bows. The bow-loading typically occurred in the deep-water sounds, Doboy and Sapelo, as these were usually larger vessels with too much draft to navigate up the river to Darien.

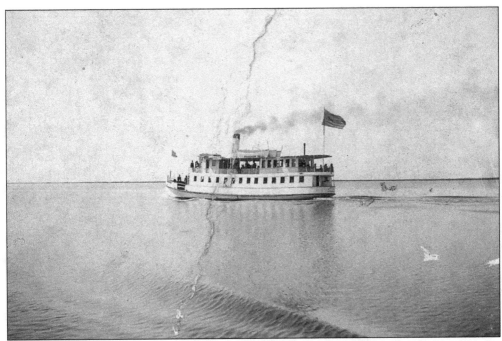

Daily steamboat service between Darien and Brunswick was inaugurated in 1887 when the *Hessie* began runs six days a week between the two towns. The *Hessie* made regular runs until 1920. Railroad development and the automobile led to the demise of the steamers.

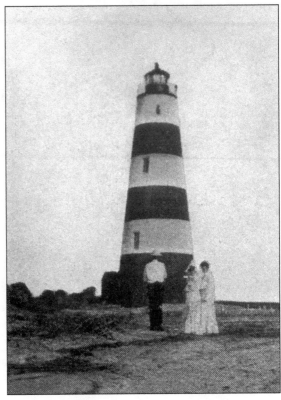

The lighthouse on the south end of Sapelo Island was the primary navigational aid for shipping entering Doboy Sound to load Darien timber. The light was built in 1820. Its daymark featured alternating red and white bands.

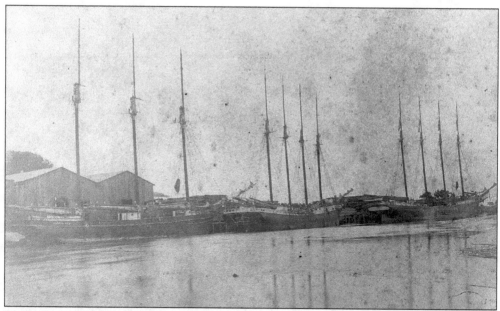

Three- and four-masted timber schooners lined the wharves along the Darien River awaiting cargoes of lumber from the local mills. Most of the lumber was destined for New England, the Mediterranean, the British Isles, Scandinavia, and South America. So much international shipping called on Darien in the late 19th century that foreign consuls from Norway, Great Britain, Denmark, and Germany kept offices at the port.

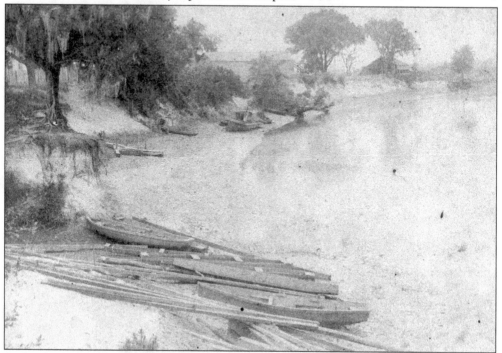

Cathead Creek was on the west side of Darien. It was a tributary of the Altamaha River. The Upper Saw Mill was on Cathead Creek and a sizable community of mill workers developed in that section of town.

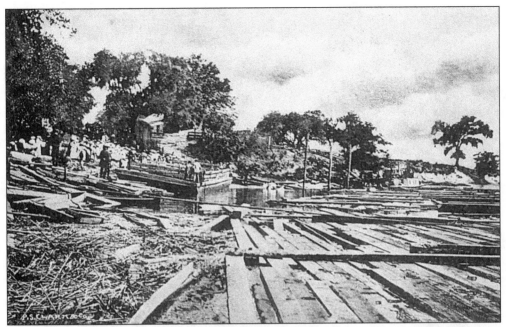

With timber rafts lining the river bank, one of Darien's African-American church congregations conducts a baptismal service.

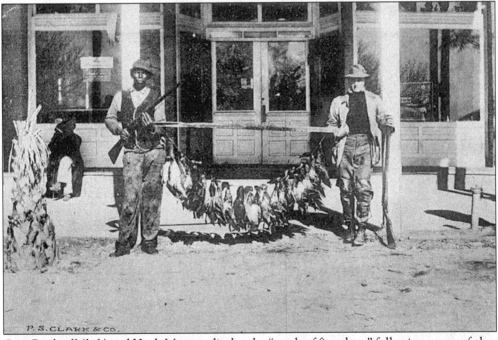

Cain Bradwell (left) and Hugh Manson display the "result of fine shots" following a turn-of-the-20th-century duck hunt in the Altamaha delta. They are pictured in front of Dr. P.S. Clark's drug store on Broad Street in Darien, which later became a general store operated for many years by James Stebbins. P.S. Clark & Co. sponsored many of the postcard views of the Darien area in the period between 1900 and 1920.

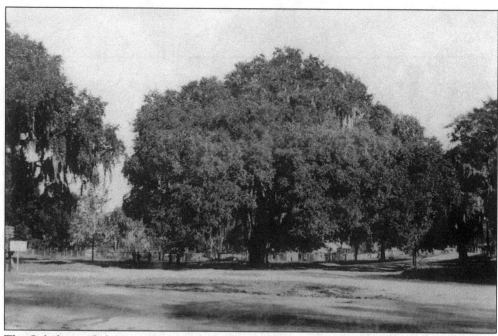

The Oglethorpe Oak was perhaps the best-known tree of coastal Georgia. The huge oak was on the courthouse lawn in Darien. Local legend insisted that the tree had sheltered Oglethorpe's Scottish Highland military forces in 1736 when Darien was settled.

This postcard view (c. 1900) depicts the salt marshes and tidal streams that are so typical of McIntosh County and the Georgia tidewater. These vistas dominated the eastern (seaward) section of the county, while the western portion featured sandy-pine flatwoods with a saw palmetto understory.

Three

THE TOWN
AND THE RIVER

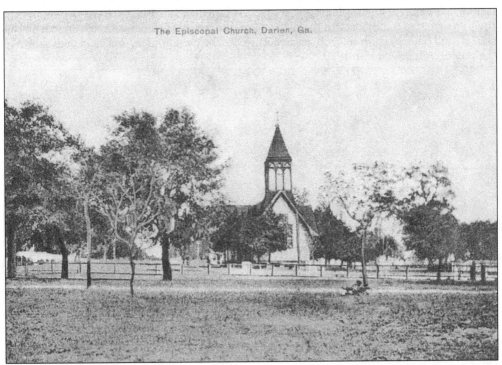

The Episcopal Church, Darien, Ga.

St. Andrew's Episcopal Church was organized in 1843. The original church edifice was burned in the 1863 Union raid on Darien. The new, and present, church was built between 1879 and 1880. This view shows the church with Vernon Square in the foreground (*c.* 1900).

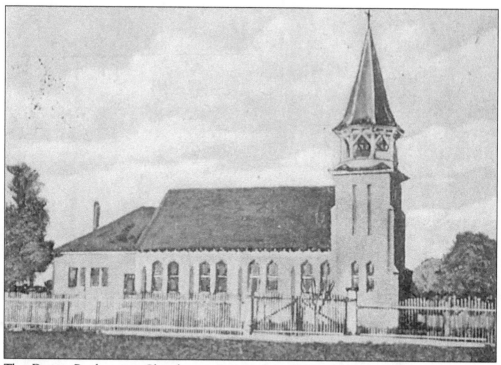

The Darien Presbyterian Church was organized in 1809, although its congregation may legitimately claim to be the oldest in Georgia. The original Scottish settlers of Darien brought their Presbyterian traditions with them when they arrived in 1736. The wooden church on this site (Bayard Square), built in 1876, burned in 1899. The present tabby-stucco church shown in the photograph was built in 1900.

Darien City Hall was constructed in 1884 adjacent to the McIntosh County courthouse. The second floor of the city hall was added in 1895. The building is still in use by the Darien city government.

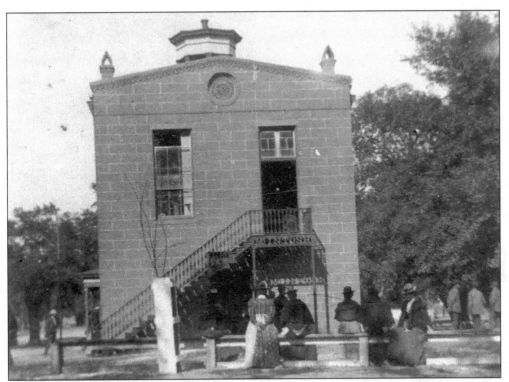

The McIntosh County courthouse in Darien was burned in the Union raid of 1863 and then rebuilt. It later burned again, accidentally this time, in 1873. This photograph shows the rebuilt structure (*c.* 1890). The outside stairs lead up to the second-floor courtroom. The building was refaced with oyster-shell stucco after a 1931 fire.

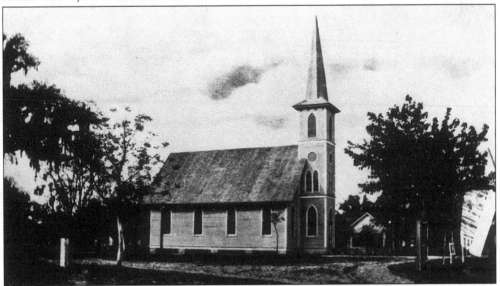

The Darien Methodist Church was organized in 1843. The building in this photograph was not completely destroyed in the 1863 fire and, therefore, was one of the few structures in town to be saved from total loss. The church was refurbished in 1884 and continues to serve the local Methodist congregation.

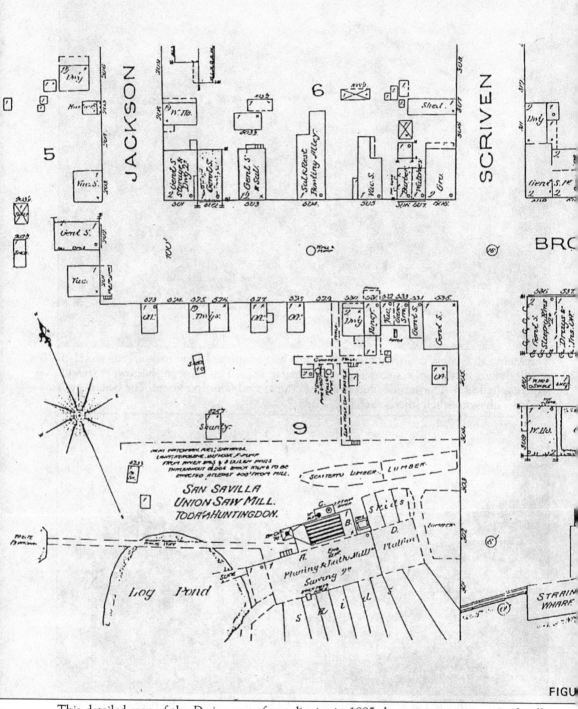

This detailed map of the Darien waterfront district in 1885 shows an energetic town hardly recognizable after the 1863 fire. Darien was a town totally reliant on a booming timber economy, a fact reflected by the waterfront sawmills, wharfs, and the Magnolia House Hotel. Walton

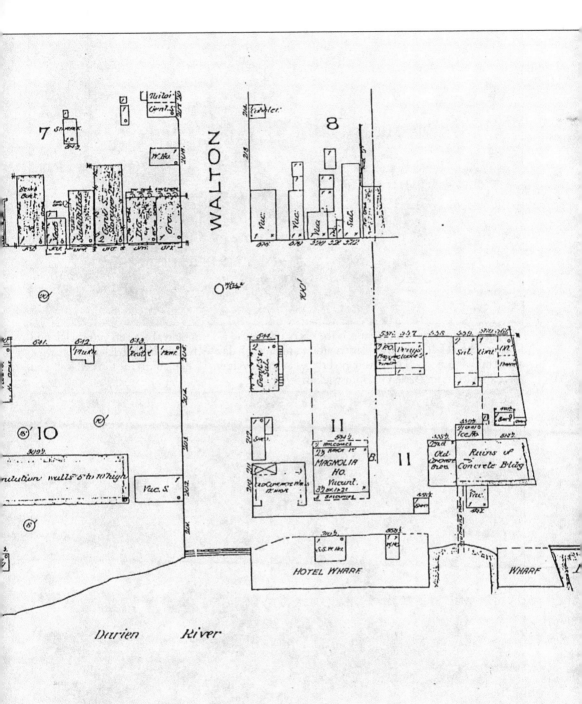

Waterfront District of Darien as of 1885

SCALE: 1" = 80 ft.
1cm = 9.7m

Street is the present U.S. 17. Broad Street was the primary business thoroughfare of late-19th-century Darien. The population of Darien at this time was about 1,700 residents.

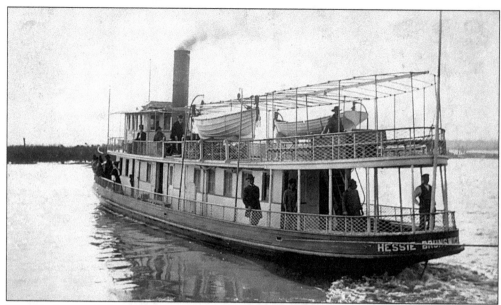

The *Hessie* provided steamboat service every day, except on Sunday, between Brunswick and Darien. The vessel arrived at Darien around noon each day with a departure back to Brunswick about mid-afternoon. There were no bridges over the Altamaha delta until the GC&P Railroad was extended from Darien to Brunswick in 1914.

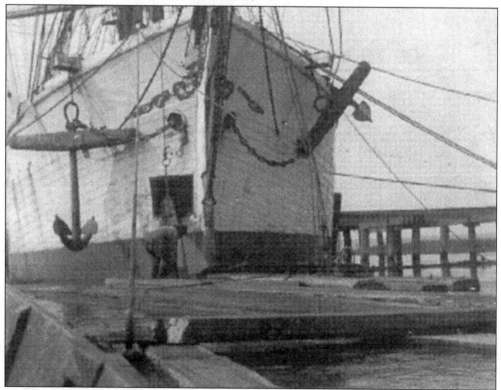

A sailing ship is shown loading squared timber beams through its bows in this photograph (*c.* 1900), probably taken at the Sapelo Sound-Front River loading grounds.

Timber ships are shown loading at Front River (*c.* 1895). Several of the larger Darien timber firms developed loading docks and facilities convenient to Sapelo Sound, a deeper harbor for larger vessels. Hunter-Benn and James K. Clarke had loading docks on Front River just east of Creighton Island. Hilton-Dodge had facilities across Sapelo Sound, near the entrance of the Julianton River.

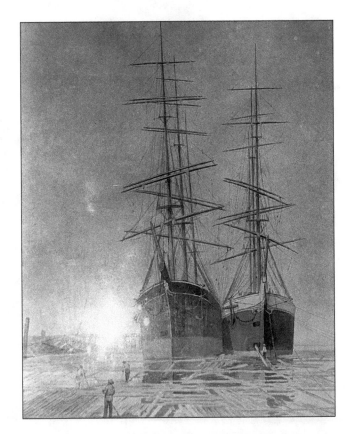

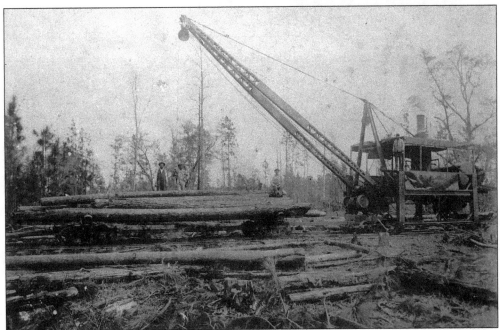

Steam-powered cranes in the early 1900s facilitated the movement of timber in the McIntosh County pine flatwoods for processing on the coast.

In 1880, the U.S. Marine Hospital Service developed the South Atlantic Quarantine Station at Blackbeard Island. The structure above is one of the quarantine buildings on the south end of Blackbeard. The station was opened as a preventative measure against the deadly yellow fever, which prevailed in southern waters during the warm-weather months of the year.

The beach on the north end of Blackbeard Island is pictured here. The island was acquired by the Navy Department in 1800 as a live oak timber reserve for shipbuilding. From 1880 to 1910, the island was utilized for the federal quarantine station.

MCINTOSH COUNTY.

PAST AND PRESENT.

By Mrs. H. S. Barclay.

A deposit of phosphates along Sapelo River, is pronounced by experts to be worthy of investigation; its nearness to the great river with its deep water, adding to its future possibilities. A ship drawing 25 feet recently crossed the bar, and a little dredging would increase its capacity to 28 feet. Congress has been memorialized time and again, and our legislators are constantly urged to. put forth the claims of our harbor to consideration. Consequently we hope in time to get the proper appropriations for its improvement; meanwhile it offers such facilities for shipping that our timber firms are a power in the land. There has been a change made recently in the timber industry, it being now nearly all sawn before shipping, whereas it was formerly mostly hewn stuff that was exported. The export of timber for the past year was 90,-000,000 feet, so says the GAZETTE, our enterprising local paper.

This article from the December 14, 1889 edition of the *Darien Timber Gazette* provides ample evidence of the importance of the timber trade to Darien and McIntosh County, as well as harbor development and the improved navigation of local waters.

COAST BREEZES.

THE LAND OF THE LIVE OAK AND GRAY MOSS.

Looking Out on the Sea Islands—The Snow White Cranes—The Dripping Springs—The Beautiful Scenes.

[Atlanta Constitution.]

McINTOSH COUNTY, GA., September 14.— [Special.]—McIntosh county has been longer recovering from the ravages of war than almost any other. Darien, having shared the fate of Atlanta, had left but three buildings with which to begin her new era. Although she has not made such rapid strides as many of her sister cities, she has steadily and solidly improved, owing to the life giving timber trade, and the extensive cultivation of rice in her immediate vicinity. During the year just past, ninety million (90,000,000) feet of timber were shipped from her port, while over one hundred thousand(100,000)bushels of tide water rice, besides large quantities of upland, are annually produced.

Yet the rest of this section, the beautiful coast county, has lain waste, patiently awaiting the wave of progress that has been sweeping over our southland. We need the outside world, and we flatter ourselves that the outside world needs us.

This *Timber Gazette* article noted that 90 million board feet of lumber were shipped from McIntosh County waters in 1888. Richard Grubb, editor of the *Timber Gazette*, was probably Darien's greatest civic booster during the heyday of the timber era.

SEA-ISLAND ROUTE

THE STEAMER

St. Nicholas,

Captain M. P. USINA.

LEAVES Savannah, from foot of Lincoln street, for Doboy, Darien, St. Simon's, Brunswick and Fernandina every

MONDAY AND THURSDAY,

NOT EARLIER THAN 4 p. m.,

City time, connecting at Savannah with New York, Philadelphia, Boston and Baltimore steamers, at Fernandina with rail for Jacksonville and all points in Florida, and at Brunswick with steamer for Satilla river.

Freight received to within half hour of boat's departure

In 1890, the steamboat *St. Nicholas* ran a weekly route between Savannah and Fernandina, with calls at Doboy and Darien.

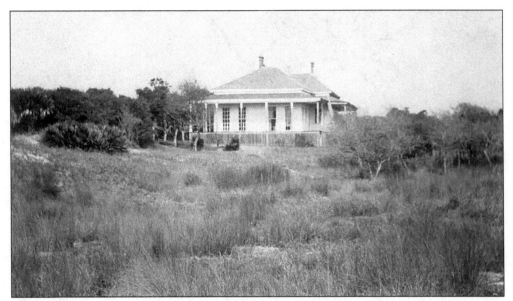

The peak activity for the Blackbeard quarantine station was in the 1890s. Pictured here is one of the Blackbeard south end hospital buildings. Typically, there were a head surgeon and six to seven support personnel stationed at Blackbeard during the yellow fever season, May to November.

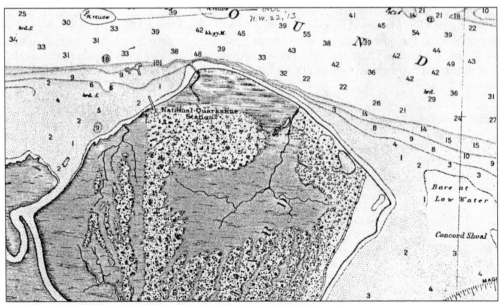

A 1905 U.S. Coast and Geodetic Survey chart for Sapelo Sound delineates the north end of Blackbeard Island and the "National Quarantine Station." It was in this area that timber ships deposited ballast rock preparatory to inspection by Marine Hospital Service personnel and, if necessary, disinfection of yellow fever contamination by using sulfur.

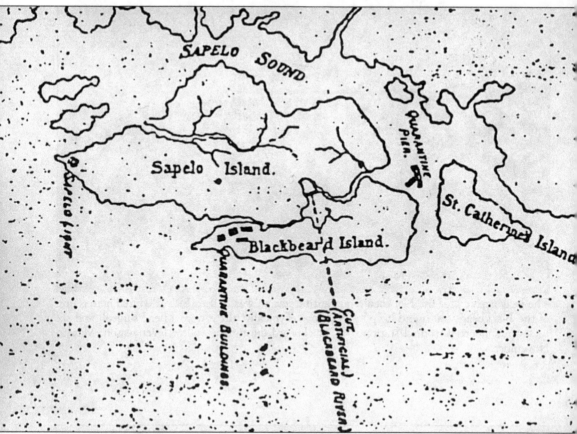

The official U.S. Marine Hospital Report for 1896 at Blackbeard Island included this rough sketch placing the quarantine station in context with Sapelo Island and the nearshore waters of McIntosh County. There was a tidal creek separating Blackbeard from Sapelo that provided the primary access between the north end quarantine facilities with those on the south end of the island.

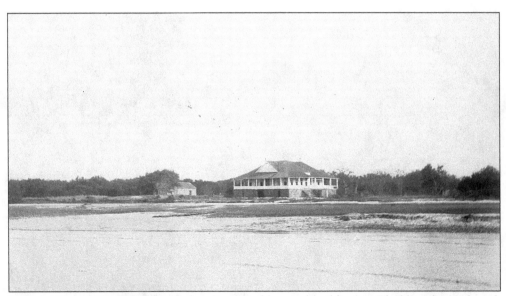

This photograph (c. 1920) shows the abandoned hospital building on Blackbeard's north end. Near this facility was the disinfection wharf and ballast piles where timber ships were inspected and processed. The quarantine station closed in 1910 and the buildings on Blackbeard were eventually dismantled and the lumber sold for scrap.

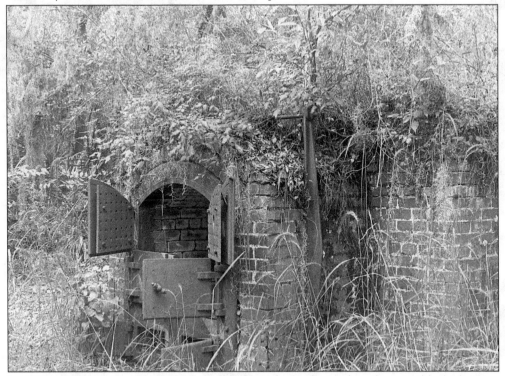

In 1904, a brick crematory was built on Blackbeard Island's north end, ostensibly for burning the bodies of yellow fever victims. Marine Hospital Service records do not note the actual cremation of any bodies on Blackbeard. In 1900 the yellow fever vaccine was developed and the threat from the disease decreased drastically.

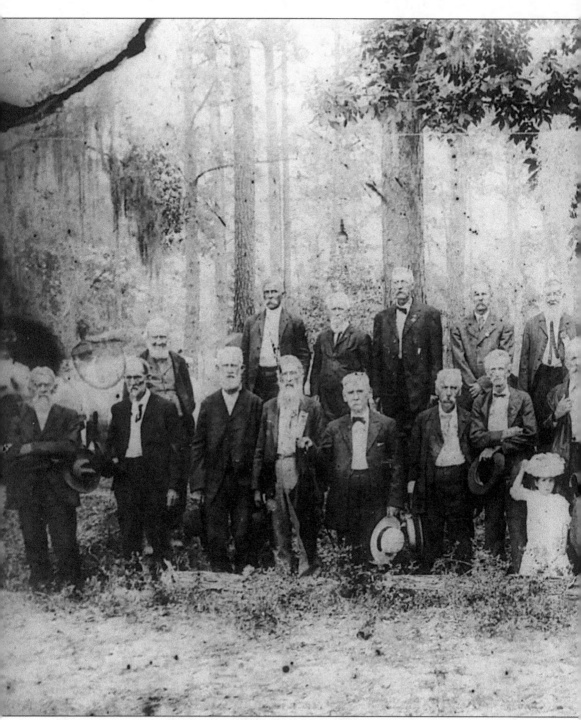

McIntosh County's John McIntosh Kell Camp No. 1032 of the United Confederate Veterans was formed in 1901. The group was comprised of local CSA servicemen, some of whom are shown in this group photo. Members of the local chapter in the early 1900s were Alexander Baillie Kell, Alexander C. Wylly, Spalding Kenan, Edward G. Cain, William H. Atwood, T.B. Blount, James Walker, John M. Fisher, S.J. McDonald, James Lachlison, Arthur Bailey,

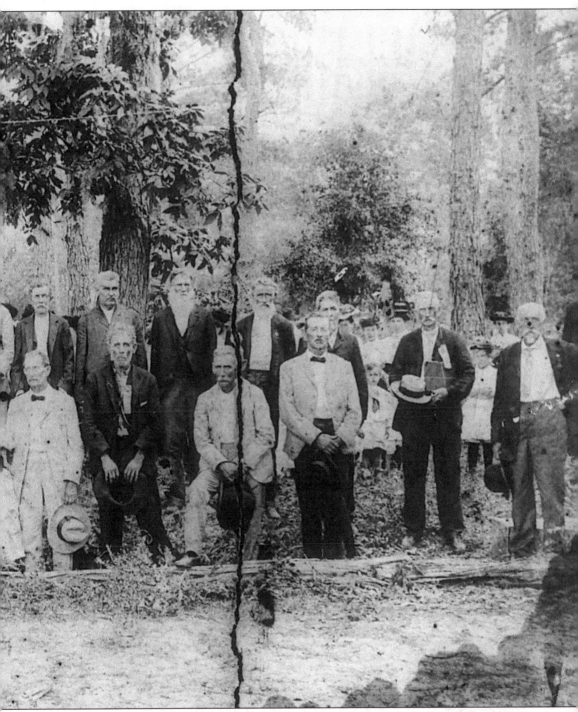

Joseph Hilton, William C. Wylly, William H. Patterson, C.H. Davis, W.C. Clark, P.S. Proudfoot, G.B. Dean, A.C. McKinley, John Muller, J.M. McIntosh, Cornelius Smith, Fred Rowe, Roland Rowe, William Thompson, J.S. Townsend, A.S. Baker, C.A. Stebbins, R.K. Walker, James L. Foster, and Mrs. Emma Strain (for the late Adam Strain).

P. S. CLARK & CO.

——DEALERS IN——

Drugs, Patent Medicines,

Oils, Paints.

SCHOOL BOOKS.

Fine Stationary,

FINE

TOILET ARTICLES.

GARDEN SEEDS.

PRESCRIPTIONS CAREFULLY COMPOUNDED.

Dr. P.S. Clark was Darien's leading druggist and one of the county's most active citizens. He lived at the Ridge and ran his drug store on Broad Street. As this advertisement from an 1893 edition of the *Darien Gazette* shows, the customer could find a good deal more than pills at the store of Dr. Clark.

A timber ship is shown at dockside awaiting a cargo in this *c.* 1900 view. This was one of the last of the wooden sailing ships engaged in this trade, as steamships had by this time begun to frequent local waters.

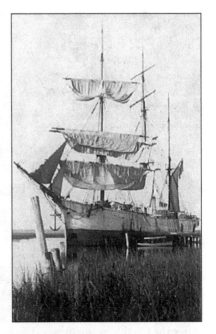

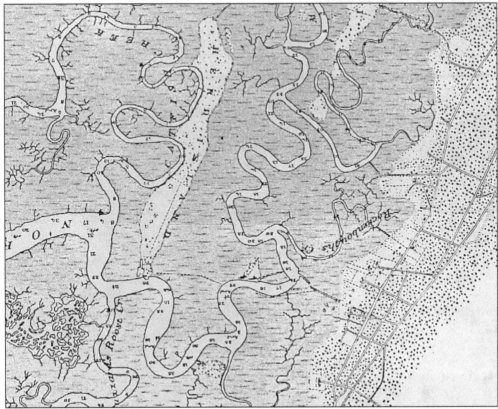

This 1895 chart delineates the environs of Darien. Shown is the plank road at the Ridge leading to Blue and Hall's landing with another plank road across the river to the Union Island sawmill. Also shown are Hird Island and its sawmill, Ashantilly, and Black Island.

After the Civil War, many wood-frame residences, such as the one above, were built in Darien, most of them of pine timber from the nearby Altamaha, which was processed at the local sawmills. This is an 1870s view.

This is another 1870s photograph of a substantial Darien residence. Locally processed lumber was inexpensive and newcomers to the town were able to construct large, fairly well-appointed residences during the 1870s and 1880s.

Four

TIMBER AND
SAPELO SOUND

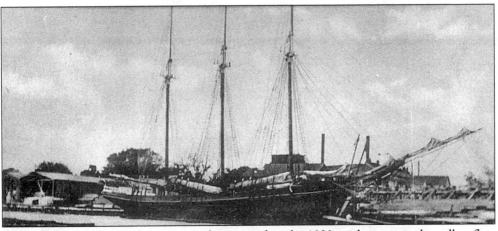

As the Darien timber market continued to expand in the 1890s with a seemingly endless flow of timber being rafted down the Altamaha River, more and larger ships began to make their appearance in the local waterways. Starting in the early 1890s, several of Darien's larger timber concerns developed loading docks and support facilities in Sapelo Sound, which had a deeper harbor to accommodate the larger steamships. Hilton & Dodge had their Sapelo Sound docks on the Julianton River, near its juncture with the Sound. Hunter-Benn's docks were at the Front River entrance where William H. Hazzard built a store and an artesian well was drilled. James K. Clarke had loading docks further down Front River where a post office, designated "Sapelo, Ga.," was opened. Front River ran along the east side of nearby Creighton Island. Smaller vessels continued to tie up and load directly at the Darien sawmills, such as the one above at Lower Bluff. For the Sapelo Sound loading grounds, drifts of timber and lumber were towed by vessels of the Darien & Sapelo Towboat Co. from Darien along a circuitous route covering over 20 miles.

WHEN IN SOUTH-EAST GEORGIA
DON'T FAIL TO VISIT

DARIEN

McINTOSH COUNTY

——

FOR ADDITIONAL INFORMATION
WRITE

Darien Board of Trade.

This promotional brochure (c. 1914) claimed Darien to be "without fear of contradiction the Garden Spot of the South. The magic touch of energy and thrift will nowhere yield a larger reward . . . Darien, the county seat with 2,000 inhabitants, has many advantages. It is but [ten] miles from the ocean, enjoys a temperate climate, has an abundance of artesian water, is electrically lighted . . . Massive live oak trees crowned with green foliage and draped with Spanish moss are everywhere to be seen. 'Tis a health giving country"

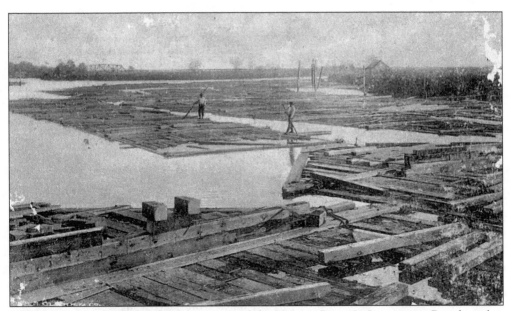

William Hunter and Robert Manson managed the Hunter, Benn & Company, a British timber firm based in Darien. Rafts of squared timber are shown gathered at the Hunter-Benn timber boom at Darien, much of it destined for towing to the Sapelo Sound loading grounds. The Manson brothers, Robert and John (who were Scotsmen), introduced golf to Darien in the 1890s. They formed one of the first golf clubs in America.

The Ridge was a residential settlement 3 miles northeast of Darien on the Shell Road, also known as the Cowhorn Road. Residents of the Ridge included timber merchants, bar pilots, and others associated with the McIntosh County's timber business.

JACKSON C R, postmaster

KENAN RANDOLPH S, dentist
Kenan Spalding, physician
Kirby John J, J K Clarke Lumber Co
Konetzko Wm, merchant and saloon
Knox Robt H, manager Hilton-Dodge Lumber Co

LACHLISON F V & CO, millinery
Lachlison James, superintendent mills Hilton-Dodge Lumber Co
Lawton John C, c, deputy collectr customs
Legare' J G, rice plantation
Livingston C L, lawyer
Lucke E W, merchant and ship chandler, (Doboy P O)

MALLARD C O S, rice plantation
McIntosh W S, city clk and treas
McKeithen T J, mnfr turpentine
Mansfield Joseph, merchant
Manson Robert, Hunter, Benn & Co

NAMIAS FORTUNATO, merchant

O'BRIEN JAMES, livery stable

PAUL ROBERT P, secy and treas Hilton-Dodge Lumber Co

Pellegreni Nicholas, fruit and confectionery
Tohis Isaac, c, grocer

RAVENAL H S, inspector-general of timber
Remler Bernhard, baker
Rothschild Charles, merchant
Ryder Rev T J, clergyman Methodist

SCHMIDT AUGUST, timber merchant
Screven Charles W, merchant
Sinclair Bros, merchants
Sinclair B T, warehouse and steamboat agent
Sinclair David S, mnfr turpentine
Sinclair W W, city marshal
Smith Rev N Keff, clergyman Presbyterian
Sparkman R L, saloon
Strain Adam, merchant, druggist and ship chandler

WALKER & BEALER, rice plantation
Walker C R, operator Darien Telegraph Co
Walker James, merchant
Walker Joseph A, merchant
Walker Reuben K, proprietor Darien Telegraph Co
Wah John, grocer
Way S A, clerk Superior Court
Weil Henry A, merchant
Weil Simon A, grocer
Wilcox Wm A, merchant

This page from an 1892 Brunswick City Directory had a separate section for McIntosh County business men engaged in trades such as timbering, turpentine, and rice planting. Also listed are a saloon keeper, steamboat agent, merchants, lawyers, and grocers.

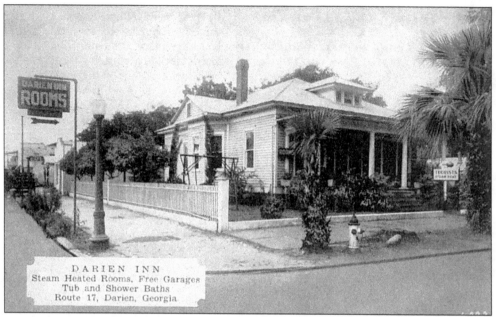

DARIEN INN
Steam Heated Rooms, Free Garages
Tub and Shower Baths
Route 17, Darien, Georgia

This building on Walton Street in Darien, shown as the Darien Inn, was later the law office of Charles C. Stebbins for many years.

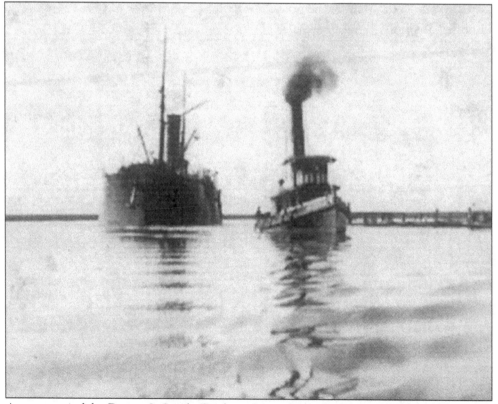

A steam tug of the Darien & Sapelo Towboat Co. is shown leading a steamship in the Front River near Creighton Island to load timber brought out from the Darien sawmills and booms.

PIERRE LORILLARD

Building a Lodge in McIntosh County Where he Can Pass the Time In Quiet.

Pierre Lorillard, the great tobacco man, has purchased a place on Harris' Neck, near South Newport river, where he is fitting up a sequestered spot for himself. Like all the rest of the business men of the world who have amazed great fortunes, he longs for a quiet nook where, as Mr. O'Shaugnessey expressed it, after buying Long Island, he could go, pull in the draw bridge after him and be out of hearing of everything that sounds like the whistle of an engine or the tick of a telegraph. Mr. Lorillard has found such a place at Harris Neck. He certainly has. At that sequestered spot he is building a club house with stables and all other comforts for a hunter's lodge. When winter comes on

In 1890, wealthy Pierre Lorillard, of the New York City tobacco family, bought property on the north end of Harris Neck in McIntosh County. He built a winter home on this location overlooking the South Newport River. He came to McIntosh County on his steam yacht on a number of occasions until his death in 1901.

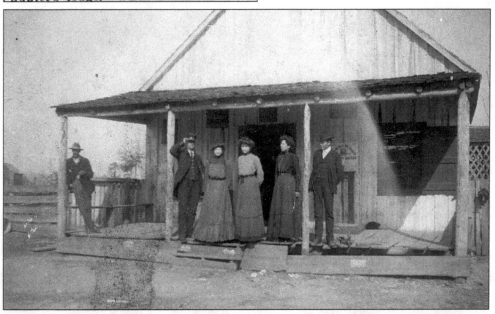

In 1893, the Florida Central & Peninsular Railroad was built through coastal Georgia between Savannah and Jacksonville, FL. The track passed through the western section of McIntosh County and a line of small depot towns grew. These were, from north to south, Jones Station, Darien Junction (later Warsaw), Townsend, Barrington Station, and Cox. The people in the photograph are shown at one of these stations awaiting the train. The FC&P was later the Seaboard Air Line Railway.

The burial ground at Ebenezer Church was in the center of McIntosh County, just south of Sapelo Bridge, which became Eulonia in 1894.

By 1895, when this advertisement appeared in the *Darien Gazette* (the *Timber* was dropped by editor Richard Grubb in 1893), the steamboat *Hessie* was making daily runs from Brunswick to Darien.

61

McC:

5

Post Office Department,

TOPOGRAPHER'S OFFICE,

Washington, D. C., *April 9*, 1898.

Sir:

To enable the Topographer of this Department to determine, with as much accuracy as possible, the relative positions of Post Offices, so that they may be correctly delineated on its maps, the Postmaster General requests you carefully to answer the questions below, and furnish the diagram on the other side, returning the same as soon as possible, verified by your signature and dated, under cover to the Topographer's Office, Post Office Department.

Respectfully, etc.,

Arrow Kaake
Topographer P. O. Dept.

To POSTMASTER AT *Sapelo, (New office,)*
McIntosh Co.,
Georgia.

The (P. O. Dept.) name of my Office is *Sapelo*

If the town, village, or site of the Post Office be known by *another name* than that of the Post Office, state that other name here: ☞ *Creighton Docks*

My Office is situated in _____ part of _____ Township, or in _____ quarter of Tract No. _____, _____ Township, County of *McIntosh*

State of *Georgia*

The name of the most prominent *river* near it is *Sapelo.*

The name of the ~~nearest creek~~ is *the Creighton river*

My Office is *3/4* miles from said *river*, on the *left* side of it, and is *on Creighton river* miles from ~~said nearest creek~~, on the *west* side of it.

My Office is on Mail Route No. _____

My Office is a Special Office supplied from *Darien Ga*, *16* miles distant.

The name of the nearest Office on my route is _____, and its distance is _____ miles, by the traveled road, in a _____ direction from this, my Office.

The name of the nearest Office, *on the same route*, on the other side, is _____ and its distance is _____ miles in a _____ direction from this, my Office.

The name of the nearest Office *off the route* is *Crescent* _____, and its distance by the most direct road is *7* miles in a *westerly* direction from this, my Office.

My Office is at a distance of *six* from the track of the *Darien & western* Railroad, on the *East* side of the railroad.

My Office is *18* miles, air-line distance, from nearest point of my County boundary.

(Signature of Postmaster) *Richard W. Lilliott*

(Date). *April 23/98*

5—3470

In the spring of 1898 the post office was opened at the Sapelo Sound timber loading grounds. It was located in the small store at the Front River timber docks of the J.K. Clarke Lumber Company. Many African-American timber workers lived on the north end of Creighton Island convenient to the loading grounds, thus necessitating the post office. The post office also served the crews of the timber ships which frequented the area. Richard W. Lilliott was the postmaster at Sapelo. Lilliott nearly lost his life during the hurricane and tidal wave that struck the coast on October 2, 1898.

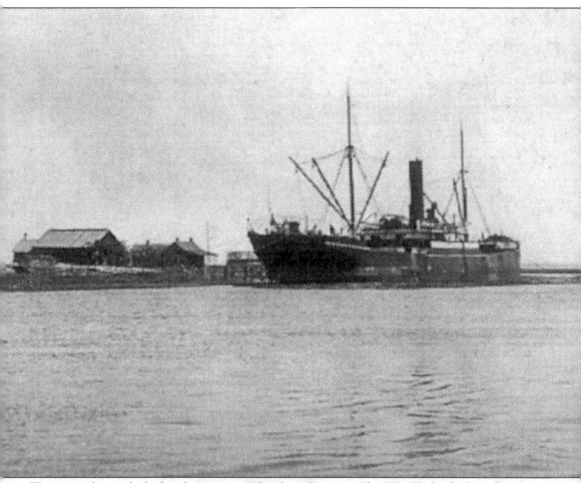

This steamship is docked and awaiting timber from Darien at the J.K. Clarke dock on Front River, a short distance from the river entrance into Sapelo Sound. These types of vessels were a common sight in that section of McIntosh County from 1895 to 1912, by which time the local timber market had fallen on hard times. "Sapelo" on the Front River continued to be designated on maps of the area into the 1920s, although little or no timber was being shipped from Sapelo Sound by that time. Note the small frame structures on the river bank amid the salt marsh. One of these housed a store and Willie Lilliot's post office.

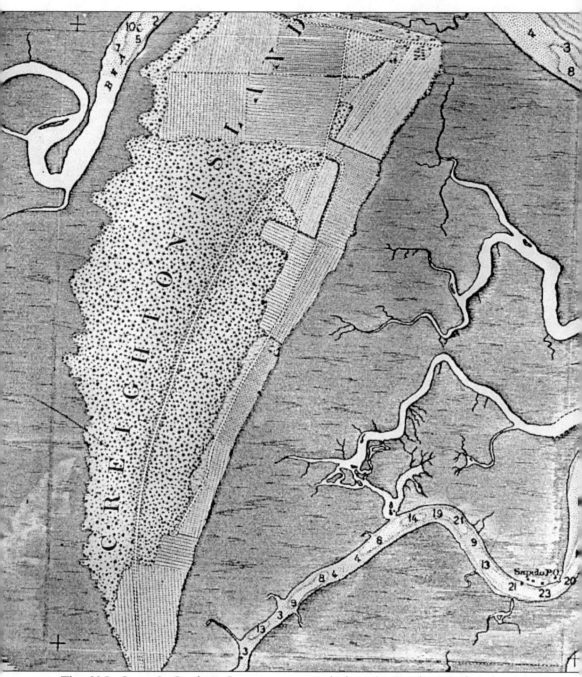

This U.S. Coast & Geodetic Survey navigational chart for Sapelo Sound is dated 1905. It delineates Creighton Island at the left. Front River is in the center of the chart. Buildings are shown at the bend of the tidal river clearly labeled "Sapelo P.O." Other buildings

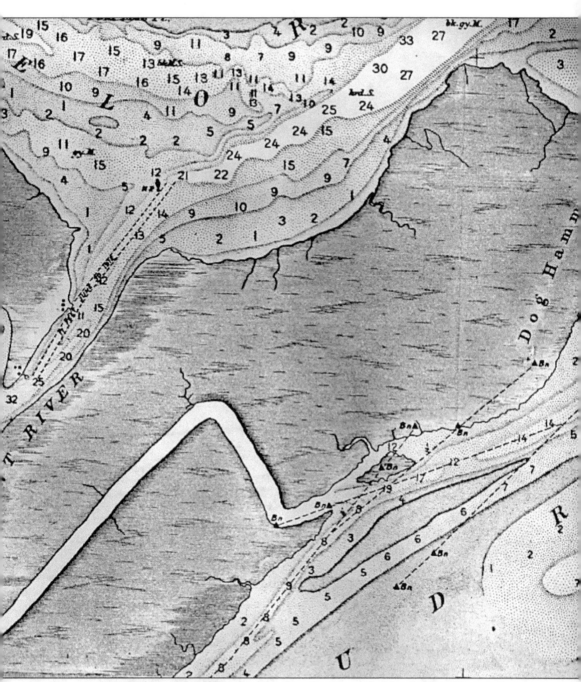

are shown further upriver at the entrance to the Sound at Hazzard's Island, where Hunter, Benn & Co. had its loading wharves.

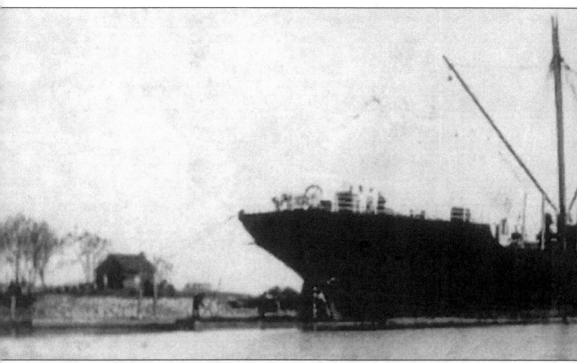

The timber steamship above is docked at the Hunter, Benn & Company's docks on the Front River near the entrance to Sapelo Sound. William Hazzard operated a store and ship supply at

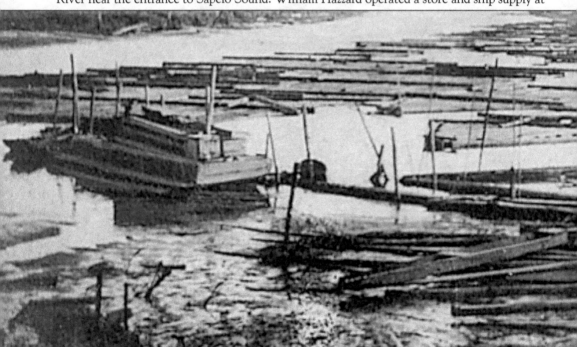

This is a lumber boom in the latter years of the industry at Darien. The amount of timber shown here belies the decline of timber shipments. In the year 1900, the amount of timber and lumber shipped from Darien waters was 112.6 million linear board feet, an all-time high locally. After

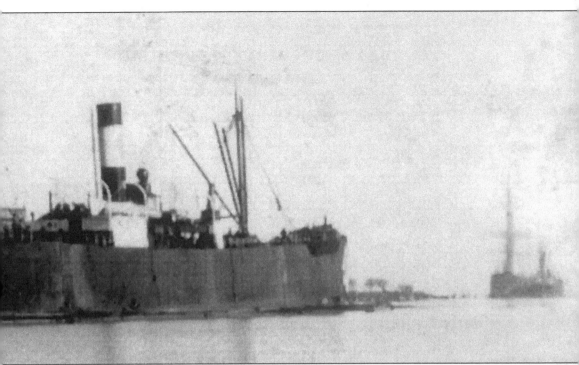

the Hunter, Benn docks for the convenience of the shipping, as well as local timber workers and towboat operators.

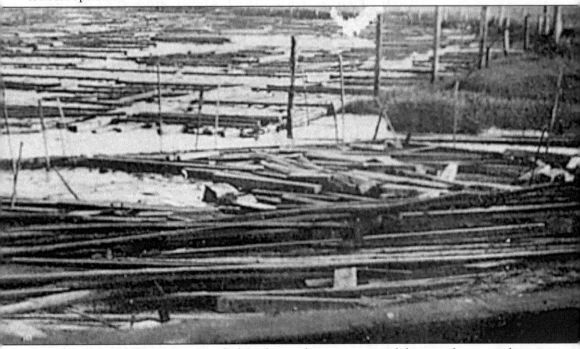

that year, the trade began a steady decline due to the overcutting of the pine forests up the Altamaha River. By 1910, timber shipments had dwindled to a mere 16 million board feet.

SUNDAY'S TERRIBLE STORM AND TIDAL-WAVE.

The Most Terrific Since The Year 1824.

The severest storm that has visited Darien, the "oldest inhabitant" says, since 1824, swept over this section with terrible force on Sunday last. While it was not quite as hard a blow as the one on September 29th, 1896, it was much longer and did more damage by long odds. The wind started to blow hard late Saturday night or early Sunday morning, but it was not until about ten o'clock on Sunday morning that it became furious and continued to grow worse until about one o'clock in the afternoon. The storm continued throughout the day and at one time it looked as if the whole town would have to succumb. The wind came from the northeast at first but gradually worked around to the east. The most terrible sight of the day was the river which had in a short time became one roaring sea, having spread all over the rice-fields and wharves. It was a real tidal-wave. It is said that the tide rose about five feet in about twenty minutes. It was from ten

On October 2, 1898, a hurricane struck the lower Georgia coast and inflicted considerable damage on Darien and McIntosh County. The storm struck on a high tide with a full moon, which produced extraordinary tide heights, covering most of the coastal islands. The local rice industry was dealt an irreparable blow, as was the timber business. Lumber gathered in the rivers was scattered far and wide by the "tidal wave" and local sawmills and ships in port were heavily damaged. Richard Grubb, in the *Darien Gazette* article above, likened the hurricane to "Noah's flood."

The weekly announcement of shipping arrivals and departures in the *Darien Gazette* is shown for a typical period in early 1900, when Darien timber exports were at their peak. Much of the shipping noted here loaded at Sapelo Sound. A mix of steamships and sailing vessels is included on the list.

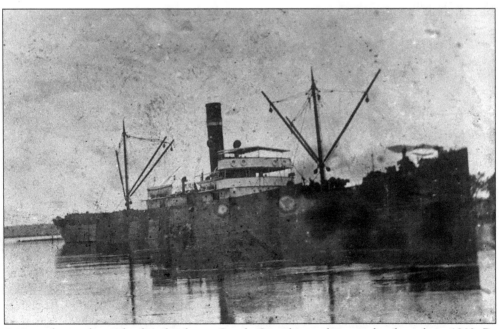

A steamship is shown loading lumber at Sapelo Sound in a photograph taken about 1909. By this time, shipments of timber from McIntosh County had severely declined.

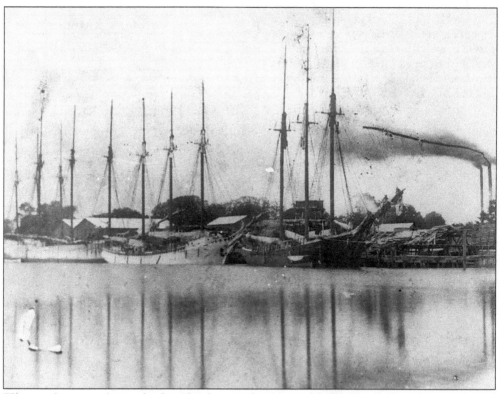

These sailing vessels are loading lumber at the Lower Bluff sawmill near Darien around 1908. Steamships drew too much water to negotiate the shallows up to Darien from the Atlantic Ocean.

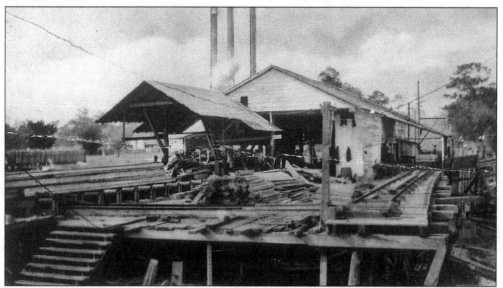

The Lower Bluff sawmill converted to smaller saws when this facility was built by the Hilton-Dodge Lumber Company in 1906. The Georgia Coast & Piedmont Railroad had a spur track running to Lower Bluff to bring in pine timber from the interior, although a great deal of timber continued to be rafted to Darien down the Altamaha River.

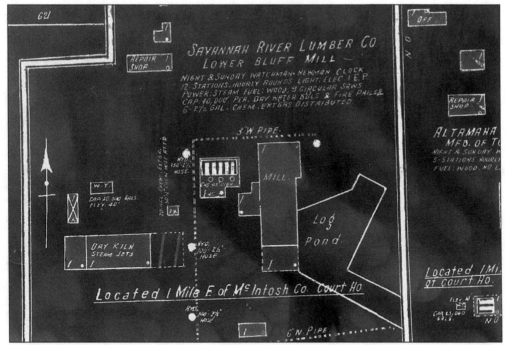

In 1916 the Hilton-Dodge Lumber Company went into bankruptcy. The sawmill at Lower Bluff was bought by the Savannah River Lumber Company and continued to operate until 1923, by which time timber had practically ceased coming into Darien from the interior.

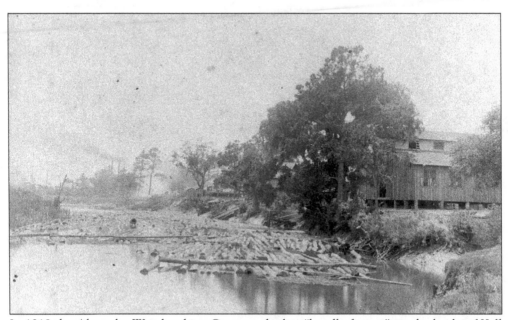

In 1918 the Altamaha Woodworking Company built a "handle factory" on the banks of Kell Creek behind the Lower Bluff sawmill. This facility manufactured wooden tool handles for two years until its closure. The Lower Bluff mill can be seen in the distance at the left of the photograph.

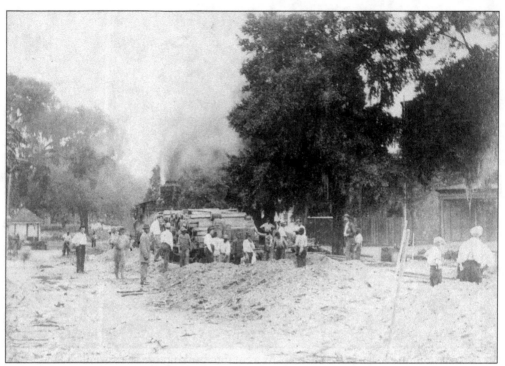

In January 1895 the Darien & Western Railroad completed its track into Darien, giving the town its first rail link with the outside world. The short-line railroad began in Tattnall County and terminated in Darien.

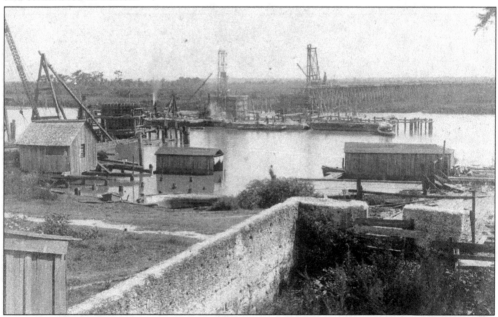

In 1910 plans were put into motion to construct bridges and trestle work over the Altamaha delta to link Darien with Brunswick by rail. Previously, Darien's only access to Brunswick was by the steamboat *Hessie* or by ferry across the delta to Hammersmith Landing on the Glynn County side of the Altamaha.

Five

DARIEN'S BRIEF RAILROAD EXPERIENCE

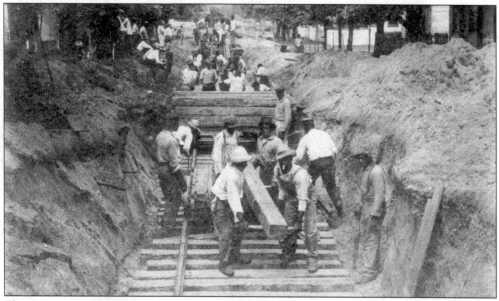

The Darien & Western Railroad succeeded the Darien Short Line Railroad, which had been created in 1889 by a group of Darien businessmen to expedite the shipment of timber into the Darien and Sapelo Sound region from the interior of Georgia. Track was laid from Collins in Tattnall County into McIntosh County, with a spur track from Crescent Station to the Sapelo River at Belleville. The spur carried timber to the Sapelo loading grounds, which had begun development in the early 1890s. The railroad finally reached Darien in early 1895. The line's terminus was at the local depot at Columbus Square. In 1906, the Darien & Western became the Georgia Coast & Piedmont Railroad.

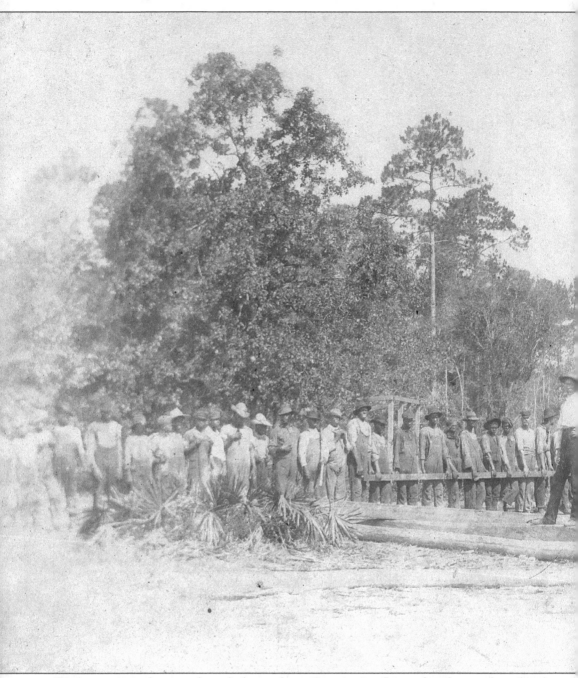

Work crews carved a route through the southeast Georgia pine flatwoods to lay out the railroad from Tattnall County to Darien. When the Georgia Coast & Piedmont took over the line in 1906, plans began to be developed for extending the line southward to Brunswick. By that time,

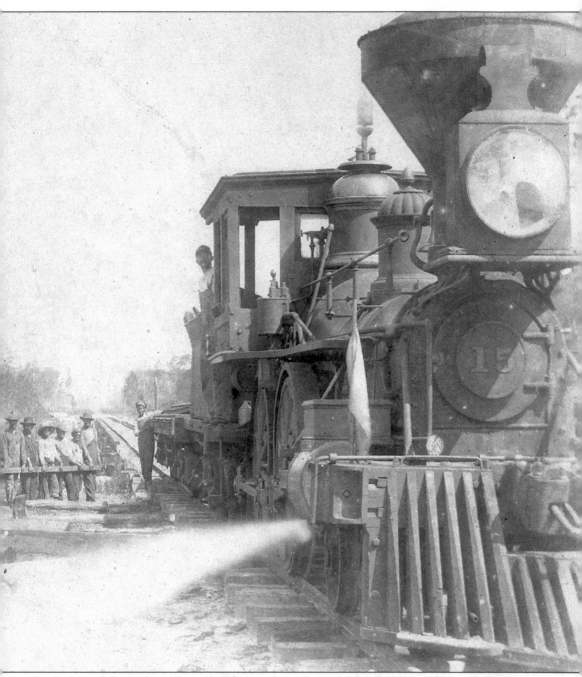

the decline of the timber industry had begun. It was hoped the railroad would save the Darien timber economy; unfortunately it came too late to do anything but delay the inevitable.

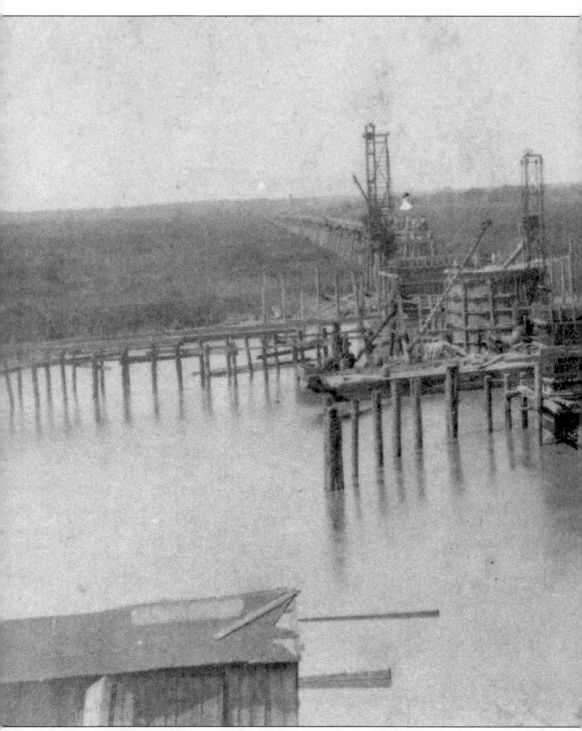

This unusual photograph was taken in 1912 from Darien's upper bluff around the location that the Magnolia House Hotel had once stood and where the present-day Welcome Center is now situated. It depicts the construction of the steel-railroad bridge across the Darien River. This is

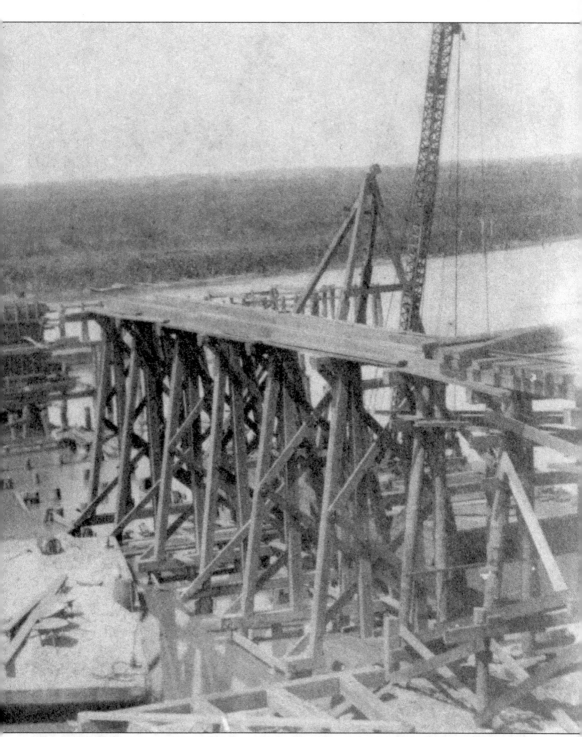

exactly where the present U.S. 17 concrete bridge now spans the river. The highway bridge was built in 1944. This view is looking south toward Generals Island. Work was completed in early 1914 when the line was finally opened from Darien to Brunswick, which was 18 miles away.

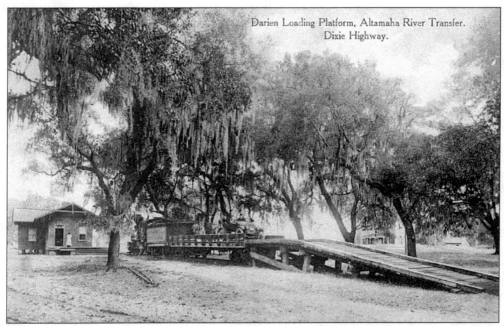

Darien Loading Platform, Altamaha River Transfer.
Dixie Highway.

The Darien Railroad Depot, open from 1895 to 1914, was located at Columbus Square. This picture was taken in 1914, when automobiles were placed on flatcars and transported across the Altamaha River into Glynn County, so that local residents could drive to Brunswick. Soon after this picture was made, the new depot for the GC&P was built on the Darien waterfront at the point where the bridge crossed the river.

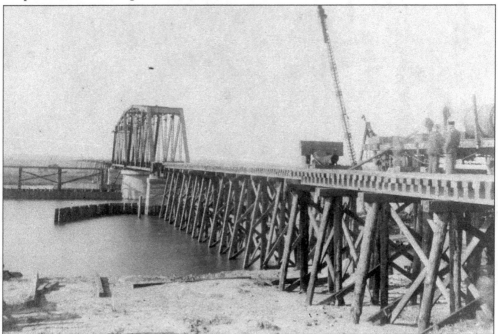

This late 1913 photograph shows work almost completed on the steel bridge and trestle work over the Darien River. A similar steel bridge was built over the south branch of the Altamaha at the present-day Two Way Fish Camp.

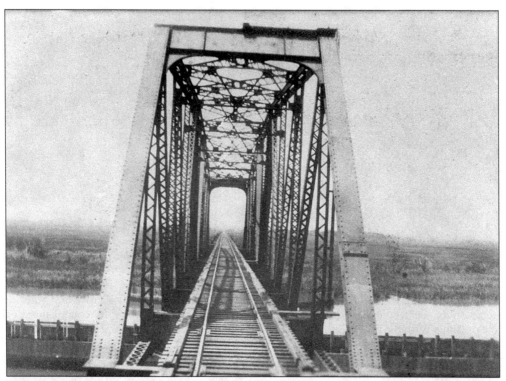

This view is looking south along the completed steel bridge over the Darien River. The marshes and old rice fields of Generals Island are on the opposite side of the river, with Butler's Island located beyond that.

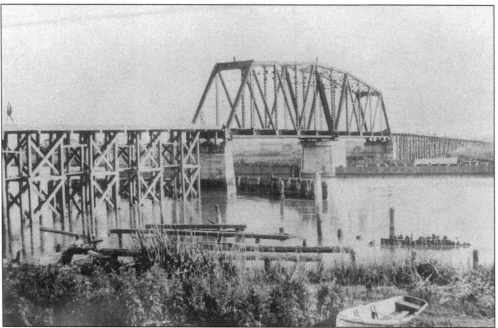

The completed bridge is shown spanning the Darien River channel. This was a swing-span bridge, which allowed shipping to access points further up the Darien waterfront.

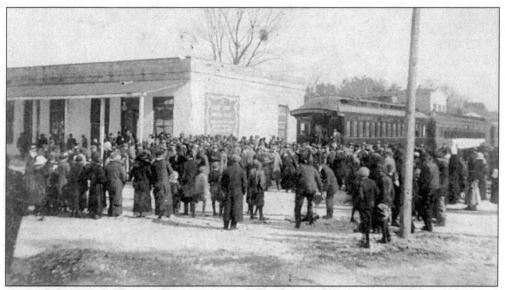

In March 1914 the GC&P ran its first train between Darien and Brunswick. It was a significant occasion for the people of Darien, as shown above by the official ceremonies commemorating the opening. With the timber industry all but dead by 1914, the railroad was seen as an economic lifeline to enhance McIntosh County's potential in agriculture and naval stores.

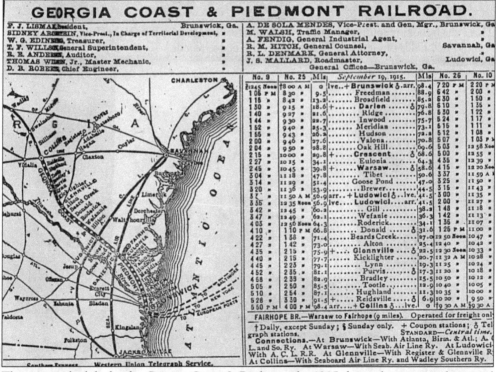

GEORGIA COAST & PIEDMONT RAILROAD.

F. J. LISMAN, President, Brunswick, Ga.
SIDNEY ARMSTEIN, Vice-Prest., In Charge of Territorial Development,
W. G. EDINING, Treasurer,
T. F. WILLIS, General Superintendent,
R. E. ANDERS, Auditor,
THOMAS WREN, Jr., Master Mechanic,
D. B. ROBERS, Chief Engineer,

A. DE SOLA MENDES, Vice-Prest. and Gen. Mgr., Brunswick, Ga
M. WALSH, Traffic Manager,
A. FENDIG, General Industrial Agent,
R. M. HITCH, General Counsel,
R. L. DENMARK, General Attorney, Savannah, Ga
J. S. MALLARD, Roadmaster, Ludowici, Ga
General Offices—Brunswick, Ga.

No. 9	No. 25	Mls	September 19, 1915.	Mls	No. 26	No. 10
12 45 Noon	†8 00 A M	0	lve..+Brunswick ♂.arr.	98.4	7 20 P M	2 20 P M
1 06 P M	8 30 "	9.5	Freedman	88.9	6 42 "	2 00 "
1 15 "	8 42 "	13.2	Broadfield	85.2	6 30 "	1 50 "
1 30 "	9 15 "	18.6	+Darien ♂	79.8	6 10 "	1 35 "
1 40 "	9 27 "	21.6	Ridge	76.8	5 30 "	1 22 "
1 44 "	9 30 "	22.7	Inwood	75.7	5 24 "	1 17 "
1 52 "	9 40 "	25.3	Meridian	73.1	5 15 "	1 11 "
1 55 "	9 43 "	26.2	Hudson	72.2	5 12 "	1 08 "
2 00 "	9 46 "	27.6	Valona	70.8	5 07 "	1 03 P M
2 04 "	9 50 "	28.8	Oak Hill	69.6	5 03 "	12 58 Noon
2 15 "	10 00 "	29.8	+Crescent ♂	68.6	5 00 "	12 55 "
2 27 "	10 15 "	34.1	Eulonia	64.3	4 55 "	12 39 "
2 45 "	10 45 "	39.8	+Warsaw ♂	58.6	4 15 "	12 20 Noon
3 04 "	11 18 "	47.8	Tibet	50.6	3 37 "	11 59 A M
3 14 "	11 29 "	51.4	Goose Pond	47.0	3 25 "	11 50 "
3 20 "	11 36 "	53.9	Brewer	44.5	5 15 "	11 43 "
3 ? "	11 50 A M	56.9	arr. +Ludowici ♂.lve.	41.5	3 10 "	11 35 "
5 35 "	12 35 Noon	56.9	lve..Ludowici..arr.	41.5	2 00 "	11 27 "
5 42 "	12 45 "	60.2	Gill	38.2	1 48 "	11 18 "
5 47 "	12 49 "	62.1	Wefanie	36.3	1 42 "	11 13 "
4 05 "	12 56 Noon	64.3	Roderick	34.1	1 36 "	11 07 "
4 10 "	1 10 P M	66.8	Donald ♂	31.6	1 26 P M	11 00 "
4 22 "	1 38 "	71.4	Beards Creek	27.0	12 50 Noon	10 47 "
4 27 "	1 42 "	73.0	Alton	25.4	12 40 "	10 42 "
4 35 "	2 15 "	75.9	+Glennville ♂	22.5	12 30 Noon	10 33 "
4 40 "	2 15 "	77.7	Kicklighter	20.7	12 32 A M	10 28 "
4 45 "	2 23 "	79.1	Lynn	19.3	11 35 "	10 24 "
4 52 "	2 35 "	81.1	Purvis	17.3	11 20 "	10 18 "
4 58 "	2 33 "	82.9	Bradley	15.5	11 50 "	10 12 "
5 05 "	2 50 "	85.5	Tootle	12.9	10 40 "	10 05 "
5 10 "	2 54 "	87.1	Highland	11.3	10 35 "	10 00 "
5 28 "	3 30 "	91.5	+Reidsville ♂	6.9	10 20 "	9 50 "
5 50 P M	4 00 P M	98.4	arr. +Collins ♂.lve.	0	†9 30 A M	†9 30 A

FAIRHOPE BR.—Warsaw to Fairhope (9 miles). Operated for freight only

†Daily, except Sunday; § Sunday only. +Coupon stations; ♂ Telegraph stations. STANDARD—*Central time.*

Connections.—At Brunswick—With Atlanta, Birm. & Atl.; A. C. L and So. Ry. At Warsaw—With Seab. Air Line Ry. At Ludowici—With A. C. L. R.R. At Glennville—With Register & Glennville R. At Collins—With Seaboard Air Line Ry. and Wadley Southern Ry.

This route schedule for the Georgia Coast & Piedmont for 1915 shows the train made several stops in McIntosh County on its daily run, including Darien, the Ridge, Inwood, Meridian, Hudson, Valona, Oak Hill (Cedar Point,) Crescent, Eulonia, and Warsaw (formerly Darien Junction), where the Seaboard Air Line intersected with the GC&P.

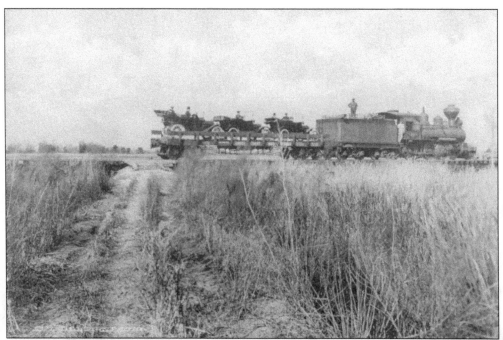

Here is a GC&P train pulling a flatcar, with several automobiles atop, on its the run across the Altamaha delta from Darien to Broadfield Siding in Glynn County, 5 miles away. This picture was taken around 1916. The people enjoyed the ride sitting in their cars as the train carried them through the bottom lands of McIntosh County's old rice delta.

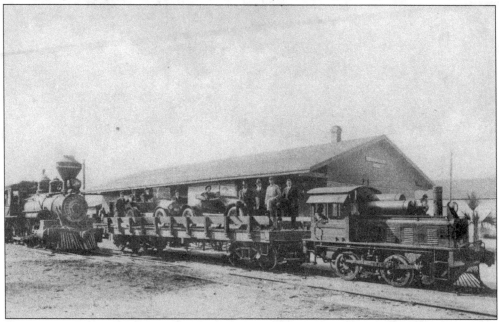

This photo from about 1917 shows the GC&P's Darien depot on Broad Street by the tracks. The steel bridge over the river is at the left of the picture. The depot building saw continued service in various capacities after the GC&P went bankrupt in 1920. The building burned in 1971.

A group of machinists and engineers pose on the train engine at the Georgia Coast & Piedmont's depot and service yard at Crescent Station, located about 12 miles northeast of Darien. This picture dates from around 1907. Crescent had a post office and a store operated by John M. Atwood. Other members of the Atwood family, especially George Atwood and

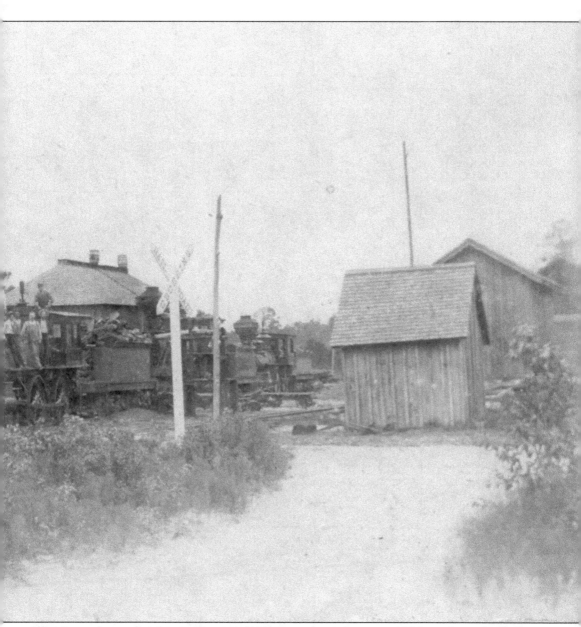

Jules Atwood, were local watermen involved in various enterprises at Valona, formerly Shell Bluff. Valona was on a tidewater creek several miles south of Crescent. Also near Crescent was Cedar Point, the home of William Henry Atwood (1836–1912,) one of McIntosh County's most prominent citizens.

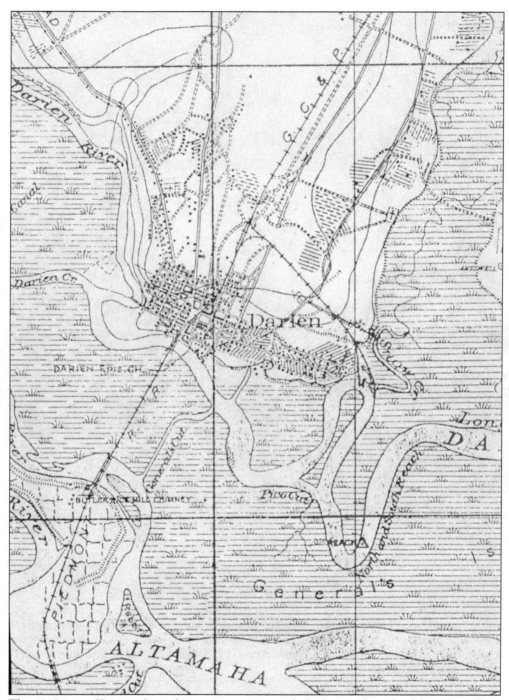

This 1919 map of Darien places the town in context with the lower Altamaha delta. The GC&P tracks are shown crossing the marshes and streams of the delta. The Lower Bluff Sawmill and the GC&P spur track leading to the mill are also shown. The GC&P went bankrupt in 1920. The trestle work and bridges over the delta were converted to accommodate automobiles in 1921 and an oyster shell road was built. This was the precursor of U.S. 17, the Atlantic Coastal Highway, which was paved in 1927.

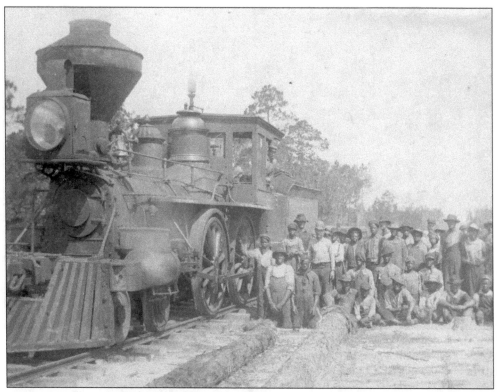

Maintenance work on the GC&P was a constant process. Here, rail workers pose beside a locomotive, c. 1910.

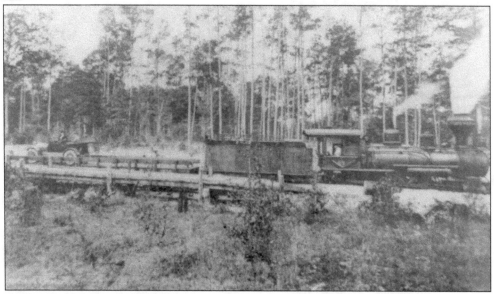

At Broadfield Siding, on the Glynn County side of the delta, vehicles were loaded and unloaded for riders motoring to and from Brunswick. Broadfield was 5 miles south of Darien and 13 miles north of Brunswick.

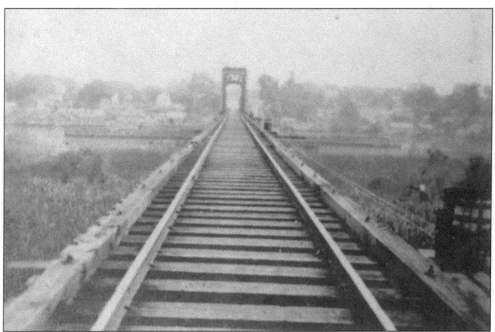

This is a view along the tracks looking north from Generals Island into Darien. The present U.S. 17 highway bridge is in this same location. The steel bridges over the delta were removed in 1944 and replaced with concrete bridges.

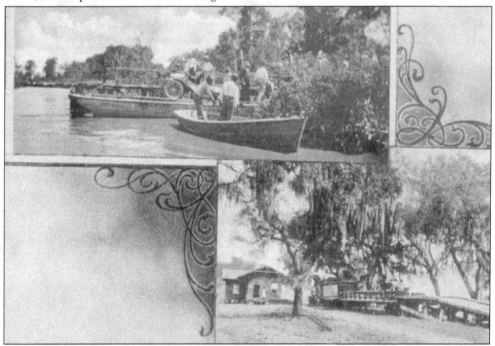

There were two ways of getting over the Altamaha delta: by way of the GC&P automobile transfer, or by the ferry barge located upriver at Fort Barrington. The Barrington Ferry operated along Post Road, which ran through western McIntosh County, crossing through the sand hills section of the county near the Altamaha.

POST OFFICE DEPARTMENT

OFFICE OF THE

FOURTH ASSISTANT POSTMASTER GENERAL

WASHINGTON OCT 25 1907

RECEIVED OCT 31 1907

DIVISION OF TOPOGRAPHY

Sir:

In order that this office may determine, with as much accuracy as possible, the relative positions of Post Offices, so that they may be correctly delineated on its maps, please carefully answer the questions below, and furnish the diagram on the other side, returning the same as soon as possible, verified by your signature and dated.

Very respectfully,

C. P. DeGraw.

Fourth Assistant Postmaster General.

To POSTMASTER AT *Meridian,*

McIntosh Co,

Georgia.

The (P. O. Dept.) name of my Office is _Meridian_

If the town, village, or site of the Post Office be known by *another name* than that of the Post Office, state that other name here: ☞ _Hudson_

My Office is situated in ____ part of ____ Township, or in ____ quarter of Tract No. _1515_ _District_ ____ Township, County of _McIntosh_ State of _Ga_

The name of the most prominent *river* near it is _Darrighan_

The name of the nearest *creek* is _Hudson_

My Office is _One_ miles from said *river,* on the _west_ side of it, and is _14_ miles from said nearest *creek,* on the _west_ side of it.

My Office is on Mail Route No. ____

My Office is a Special Office supplied from _Trains_ _78 yds_ miles distant.

The name of the nearest Office on my route is _Melone_, and its distance is _3_ miles, by the traveled road, in a _N. E._ direction from this, my Office.

The name of the nearest Office, *on the same route,* on the other side, is _Crescent_ and its distance is _4_ miles in a _North_ direction from this, my Office.

The name of the nearest Office *off the route* is _Townsend_, and its distance by the most direct road is _9_ miles in a _West_ direction from this, my Office.

My Office is at a distance of _78 yds_ from the track of the _Georgia Coast & Piedmont_ Railroad, on the _west_ side of the railroad.

My Office is _15_ miles, air-line distance, from nearest point of my County boundary.

(Signature of Postmaster) _M. E. Durant_

(Date) _Oct 28 1907_

5—3470

This document from 1907 reveals information about the post office at Meridian, located on Cowhorn Road near the GC&P railroad track about 7 miles northeast of Darien. Meridian was established in 1896 as a station for the Darien & Western Railroad. The postmaster at the time of this report was M.E. Durant. Members of the Durant family lived at Meridian and served as postmasters for many years in the early 20th century.

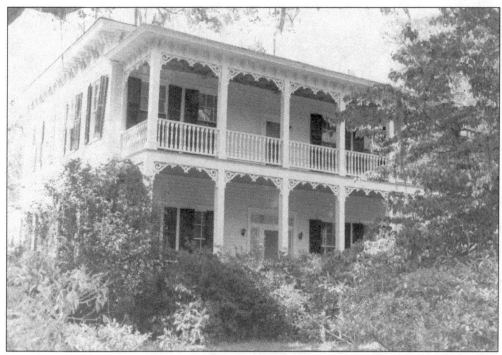

The Downey House at the Ridge was built in 1875 by William Downey of McIntosh County. Downey was engaged in Darien's lucrative timber business. In the early 1990s, the house was dismantled, moved, and rebuilt on St. Simons Island.

Col. Charles M. Tyson was involved in Darien timber, and was president of the Darien Bank from 1915 to 1940. The Darien Bank was founded in 1889 during the peak years of Darien's timber trade. Tyson built the house above on the Ridge in 1890.

This advertisement from the April 13, 1907 edition of the *Darien Gazette* reflects a period when the town's business fortunes had peaked. The depressed timber market had settled in by that time. As the supply of timber coming into Darien dwindled, so too did the town's economy. With the coming of World War I, Darien and McIntosh County had entered an economic slump and the town's population declined.

B. ASMAN.

SPRING AND SUMMER OF 1907!

I have just received a new line of the latest style of suits, shoes, hats, for men, women, and children, from the highest to the lowest prices. Come in and shake hands with the new summer styles. Get acquainted with 'em. Some of the extreme shapes may scare you a little at first, but there are a good many young men in this city who appreciate new styles and want 'em while they are new—before everybody has 'em. Come in to see us and you will save money. We also

This c. 1910 photograph was taken in front of the McIntosh County Courthouse in Darien. Shell Road, which leads to the Ridge, is in the background, as is the county jail building, built in 1891.

The unusual thing about this early 1900s postcard is that—despite the caption, which reads "Greetings From Crescent, Ga."—the scene does not appear at all to be from Crescent, or anywhere near McIntosh County. The vegetation is more suggestive of the uplands, perhaps the mountains, rather than the coastal Georgia lowlands.

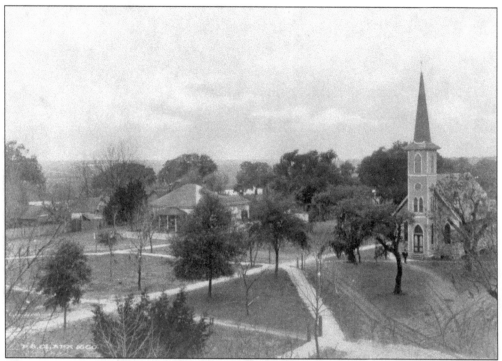

This view, looking southwest, is of Vernon Square in Darien about 1910. On the right is the Methodist church. The oaks in the square are much smaller than they are today and the street pattern around the square is slightly different.

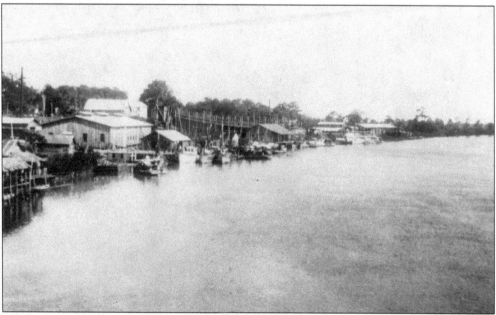

The Darien waterfront is shown east of the railroad bridge in this 1918 photograph. In the center of the picture a large wooden vessel is under construction, the first project of the short-lived Darien Shipbuilding Company, which was founded by local businessmen led by C.M. Tyson and was funded by the Darien Bank.

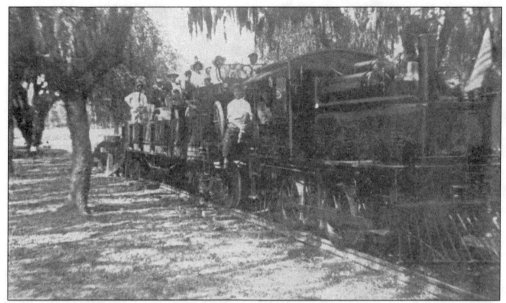

A smaller GC&P tow transfer engine is ready to transport local patrons across the Altamaha to the Glynn County side of the river.

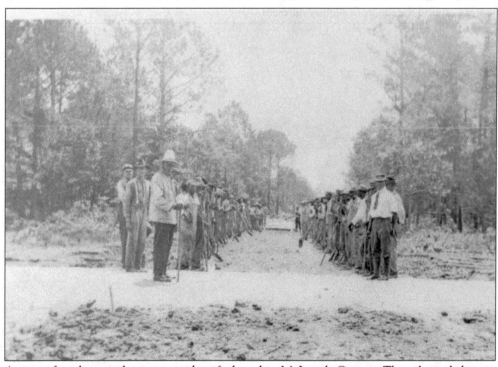

A gang of workers works on an unidentified road in McIntosh County. The telegraph line in the background suggests this picture was taken near the railroad.

Six

MᴄInᴛosʜ Cᴏᴜɴᴛʏ's
Oᴜᴛʟʏɪɴɢ Sᴇᴛᴛʟᴇᴍᴇɴᴛs

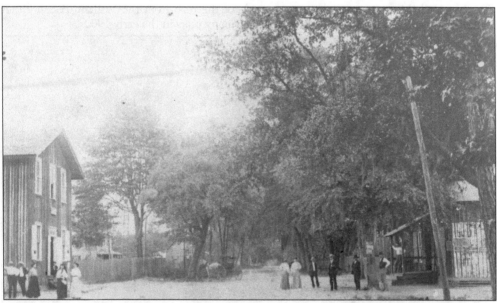

The forerunner to the present U.S. 17 was this sandy road, which had connected Savannah to Darien since colonial times. On the left are the store and post office first run by O.S. Davis, then by William Bacon, and still later by Olney Jenkins. It was Davis, when applying for a post office permit in 1894, who proposed the name of Eulonia for the small community, which previously had been known as Sapelo Bridge (there was already a "Sapelo" post office in McIntosh County, at the Sapelo Sound timber loading grounds.) Sapelo Bridge was the original county seat of McIntosh before it was moved to Darien in 1816. This photograph of Eulonia was taken around 1907.

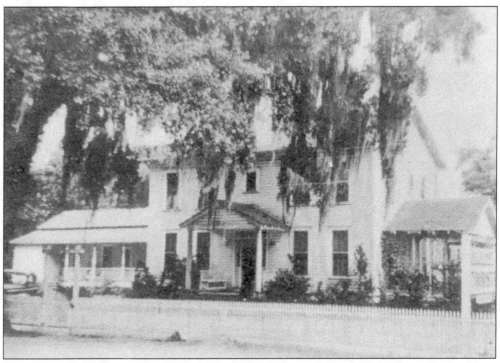

The McIntosh Manor was on the opposite side of the road from the William Bacon-Olney Jenkins store at Eulonia. It was a tourist home for many years in the early 1900s.

A brick schoolhouse was built in Townsend in the early 1900s. Townsend was in western McIntosh County, 6 miles west of Eulonia on the Seaboard Air Line Railway. It had been developed in the 1890s, when the railroad was built through that section.

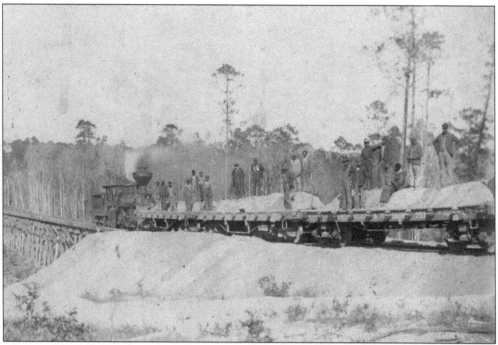

This *c.* 1910 Georgia Coast & Piedmont Railroad activity took place in western McIntosh County near Darien Junction (known as Warsaw after 1915). Darien Junction was the point where the GC&P and the Seaboard Air Line intersected, several miles north of Townsend.

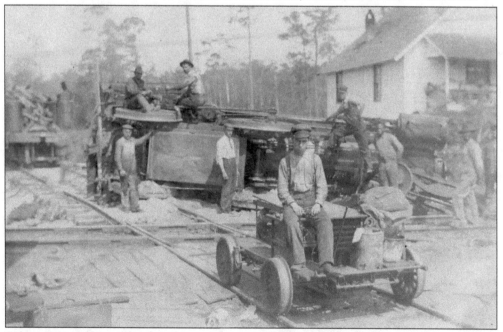

Sidney Britt is the unhappy-looking young man sitting atop the rail motor car in this 1907 scene of an overturned Georgia Coast & Piedmont engine at Darien Junction. Warsaw had an active sawmill and naval stores in the 1920s and 1930s. It disappeared as people began moving away not long after the sawmill burned in 1934.

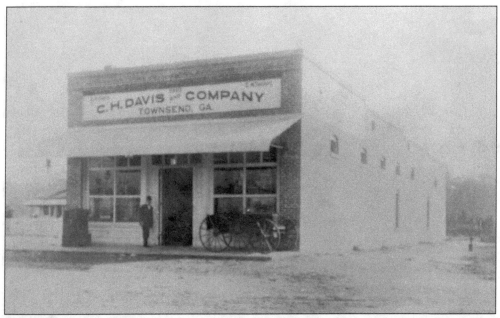

The store of C.H. Davis and his son-in-law, Elisha M. Thorpe, was an active business of Townsend in the early 1900s. This photograph was taken soon after the store was built in 1910. Townsend was an important naval stores center. In the 1920s, it was the home office of the Georgia Land and Livestock Co., which owned much of the acreage in western McIntosh County for cattle grazing purposes.

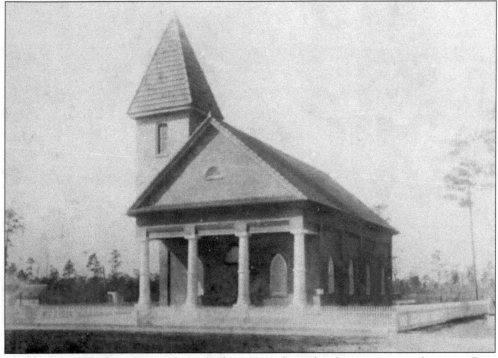

The Townsend Methodist Church was built in 1909. One of its first pastors was the young Rev. Arthur J. Moore, who later became bishop of the Methodist church.

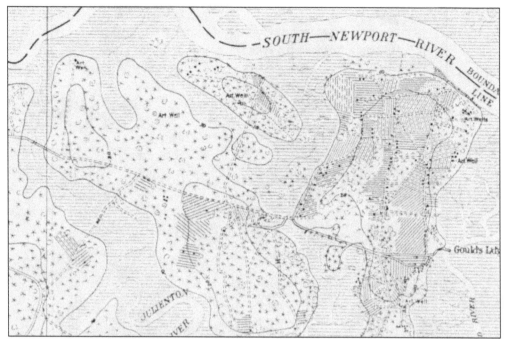

In the northeast section of McIntosh County, flanked by tidal salt marshes and the South Newport River, was Harris Neck. This 1918 government map shows the layout of agricultural fields at Harris Neck where the descendants of plantation slaves lived and farmed. This was the old Peru plantation of Jonathan Thomas before part of the land became the Lorillard estate.

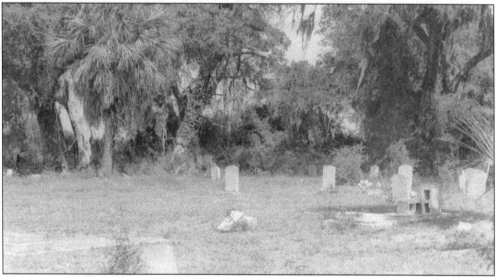

The Gould Cemetery at Harris Neck was an African-American burial ground dating to the late 1800s for freedmen who acquired land on the former plantation. In 1940, the black residents of the section were displaced when the federal government confiscated the upper end of the Neck for an army air-training facility. Harris Neck Army Airfield operated during World War II. After the war, the base closed and the property eventually became a federal wildlife refuge rather than the land reverting back to its former black owners. Much controversy ensued over this, which persists to the present.

Series 1929

Number 6

UNITED STATES DEPARTMENT OF AGRICULTURE

Soil Survey

of

McIntosh County, Georgia

By

G. L. FULLER
Georgia State College of Agriculture, in Charge

and

B. H. HENDRICKSON and J. W. MOON
United States Department of Agriculture

Bureau of Chemistry and Soils

In cooperation with the
Georgia State College of Agriculture

For sale by the Superintendent of Documents, Washington, D. C. - - - - - - - - - Price 10 cents

The first comprehensive soil survey for McIntosh County was compiled by the U.S. Department of Agriculture in 1929. The early 20th century saw a focus on the agricultural potential of the county. This included the cultivation of truck crops on the former rice lands of the Altamaha delta and the open pasturage of livestock in the pine flatwoods of western McIntosh County. Also significant in McIntosh County at this time was the naval stores industry, especially the gathering of pine sap for the distillation of turpentine in the western sections of the county.

Seven

THE MCINTOSH COUNTY FISHERY

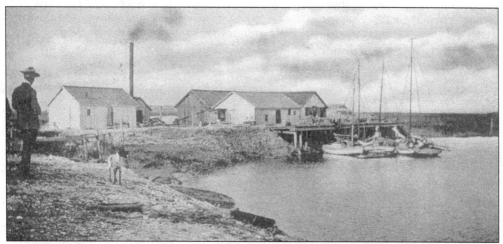

With the gradual demise of the lumber industry in the first decade of the 20th century, the people of Darien and McIntosh County turned to other sources of income. One was the naval stores industry, particularly turpentine. The untapped pine forests of western and upper McIntosh County were prime sources for the resinous sap that was collected from the trees and distilled into spirits of turpentine in the numerous stills around McIntosh County. The other livelihood that began to attract increasing numbers of local citizens was that of the harvest of the sea. The commercial harvest of shellfish, primarily oysters, began in earnest in McIntosh County in the 1890s. By the early 1900s there were oyster canneries at several places along the county's coast. The one shown in this photo (dated 1906) is at Valona, operated by the Shell Bluff Canning Company. The Valona cannery was managed by J.L. Atwood and Robert Strain. Shown along the banks of Shell Bluff Creek are single-masted oyster sloops, which gathered the oysters from the local mudflats during the winter.

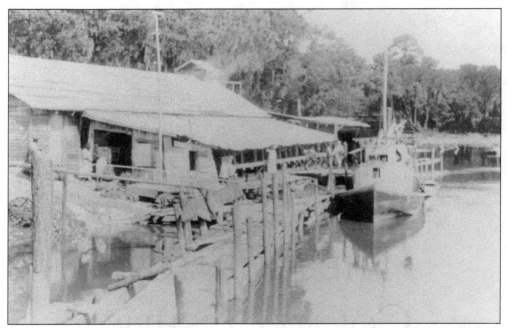

An oyster cannery operated in the 1930s and 1940s at Cedar Point, located between Valona and Crescent. The canneries employed large numbers of McIntosh County's African-American population, who worked as "shuckers" removing oysters from the shells preparatory to packing. African Americans also comprised the majority of those workers who went out in their flat-bottomed boats (bateaux) to gather the oysters in the rivers and creeks at low tide.

Shrimp boats began to be built in McIntosh County in the years after World War I. This is one of the early trawlers from the shrimp fleet at Valona. In the years following World War II, hundreds of young men back from the service joined the growing shrimping industry and McIntosh County's fleet became the largest on the Georgia coast.

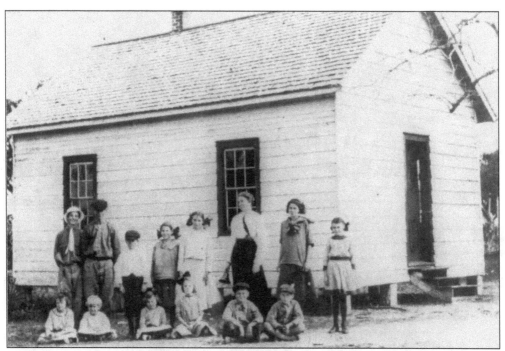

The schoolhouse and students at Valona are shown in this 1912 photograph. The Valona school was operated by McIntosh County from 1907 to 1917. Pictured, from left to right, are the following: (sitting) Jane Atwood, Sophie Atwood, Maggie Durant, Mary Durant, Hugh Burrows, and Stuart Atwood; (standing) Paul Dunwoody, James Atwood, Alex Durant, Salome Atwood, Claire Burrows, Miss Mattie Buckner, Lewis Burrows, and Emma Dunwoody.

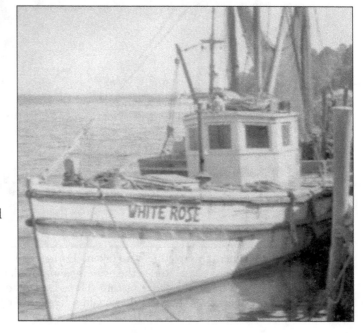

The *White Rose*, shown *c.* 1946 docked at Cedar Point, was operated by Earl Sullivan, Owen Hunter, and Bill Hubbard, all young men just back from World War II. Sullivan and Hunter are the father and uncle, respectively, of the author of this book.

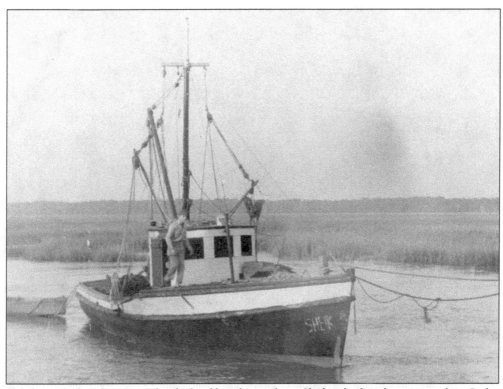

Floyd Atwood is shown on the deck of his shrimp boat *Sheik*, which is being towed in Cedar Creek. Creighton Island is in the background.

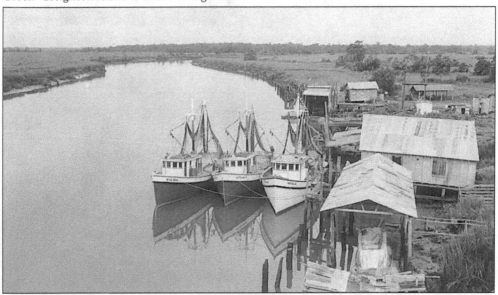

By the mid-1950s, when this picture was taken, Darien had become one of the leading shrimping ports on the east coast. Notice the evolving, improved, boat designs from the vessels in this photo and the *Sheik* in the above picture. These Darien boats were the first generation of a larger class of "blue water" trawlers that could tolerate the rigors of fishing in the rough open sea.

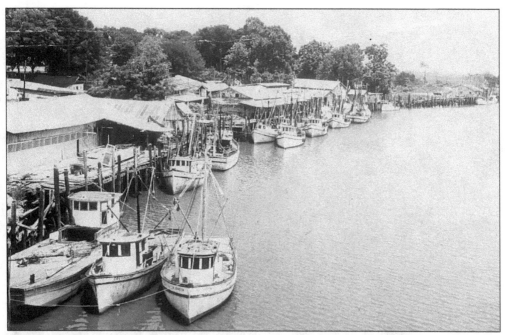

The shrimp boats and oyster barges of the Ploeger-Abbot Seafood Co. of Darien represented the largest single segment of McIntosh County's commercial fishery during the heyday of the industry between 1945 and 1973. This view is looking east from the Darien River bridge.

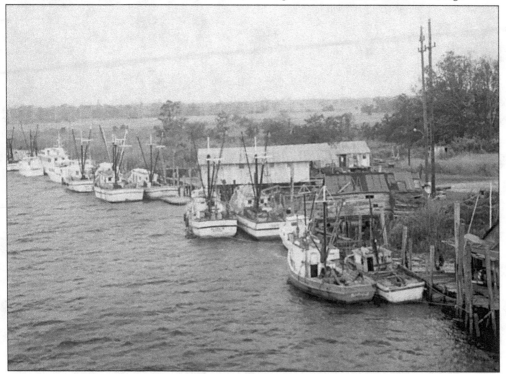

Darien's waterfront is shown as it appeared in 1960. Among the leading families involved in the Darien shrimp industry were the Ploeger, Boone, Gale, Skipper, and McQuaig families.

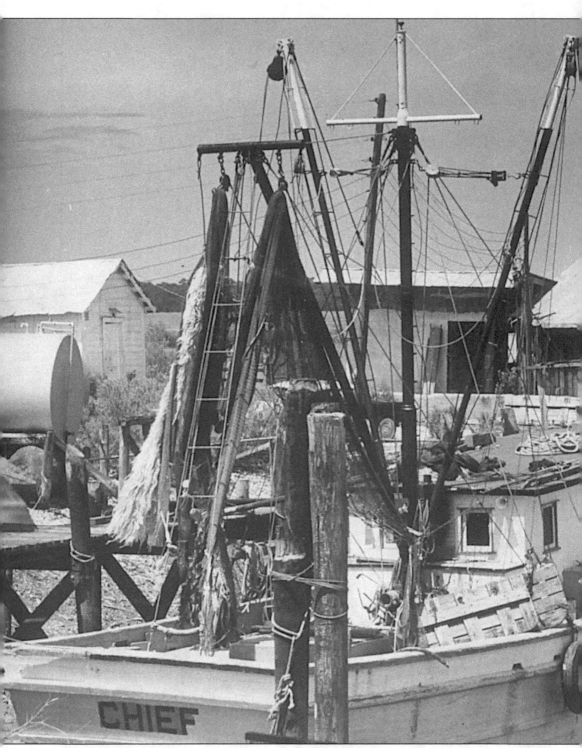

These shrimp boats are moored at the docks of Alex Durant at Valona, c. 1962. The Valona-Cedar Point area of McIntosh County was home to a large shrimp fleet. First generation shrimpers at Valona were Alex Durant, Hunter Watson, Stuart and Floyd Atwood, and Hugh

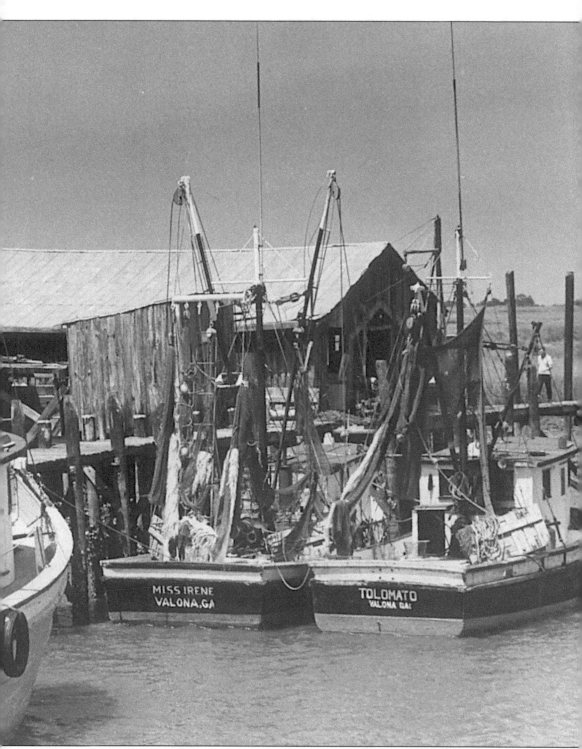

Burrows, followed by G.Y. Redding, Marion Hagan, Peter and George Kittles, Fred Todd, and Guy Amason. J.W. Brannen and Jack Ward were Belleville shrimp boat owners. Pioneer blacks in the fishery included Henry Curry, Dan Thorpe, and James Baker.

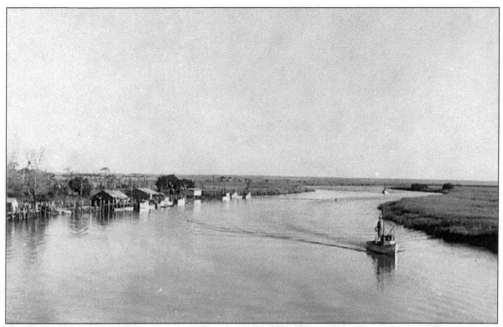

A shrimp boat glides up the Darien River in this *c.* 1955 photograph. In the 1950s and 1960s, Darien was alive and energetic on the strength of its fishing industry, an atmosphere reminiscent of the old timber and sawmill days of earlier generations.

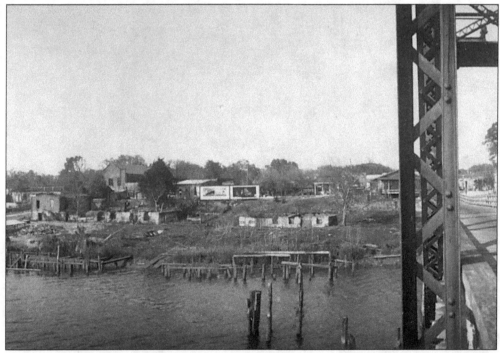

Soon after the GC&P went bankrupt, its steel railroad bridges were converted to automobile use. It was officially opened to traffic in July 1921 and became part of the Atlantic Coastal Highway (U.S. 17) when the route was paved through coastal Georgia in 1926 and 1927. This view is of the bridge looking north.

Eight

DARIEN AND MCINTOSH COUNTY: 1925–1960

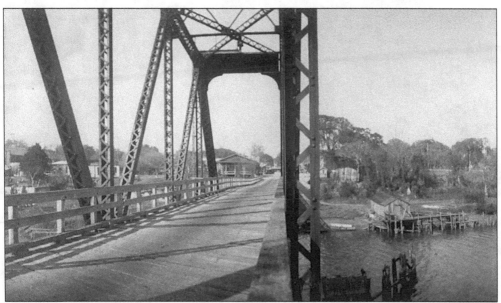

Darien and McIntosh County suffered through severe economic hardships in the 1920s and 1930s. The end of the timber trade, which had centered on Darien for so many years, accompanied by the demise of the Georgia Coast & Piedmont Railroad, put the county into an economic depression. Relief only came with the advent of World War II, with new job opportunities available in the Brunswick shipyards, and the surge in growth of the seafood harvesting and packing industries after the war. The view above is the former railroad bridge converted for automobile use. Note the train depot in the center of the photo between the steel girders.

In 1923, Col. Tillinghast L. Huston of New York City purchased Butler's and Champneys islands in the Altamaha delta. Huston was part owner of the New York Yankees baseball team when Babe Ruth was emerging as the leading figure of the sport. At the time of Huston's purchase, the railroad bridge over the Butler River, south of Darien, had been converted to automobile use. Like the steel bridges over the Darien and South Altamaha Rivers, it was a one-lane bridge. The wooden bridge over the Butler River is pictured above. To the right of

the bridge, in the distance, is the brick rice mill chimney of the former Butler plantation. The building to the right of the mill is the barn and packing house. Further to the right is the white three-story residence built on Butler's Island by Colonel Huston in 1927. Colonel Huston used Butler's Island as a winter residence. The Coastal Georgia Experimental Agriculture Station was located on Butler's Island in the 1920s and 1930s. Huston engaged in truck-crop farming on the island. He also started a dairy business.

With the demise of the Georgia Coast & Piedmont, the track bed and trestle work through the Altamaha delta south of Darien was surfaced with oyster shells for automobile use. This view was taken looking north around 1921 from Butler's Island. Several years later, the road was macadamized when U.S. Highway 17 was built along the Georgia coast.

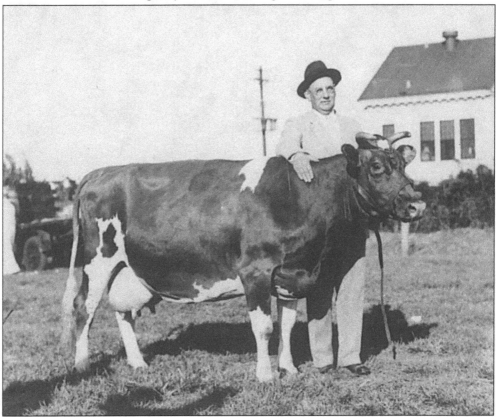

Col. T.L. Huston is shown c. 1935 with one of his prize, pure-bred, milk cows on Butler's Island. Some of Huston's dairy structures are still standing.

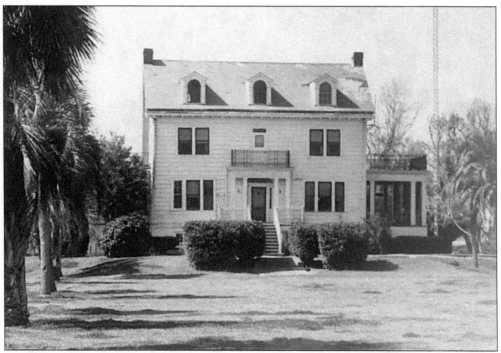

The Huston residence on Butler's Island was built in 1927 on the site of the old overseer's cottage, where Pierce Butler, Fanny Kemble Butler, and their two children stayed for two months during their visit to Georgia in the winter of 1838.

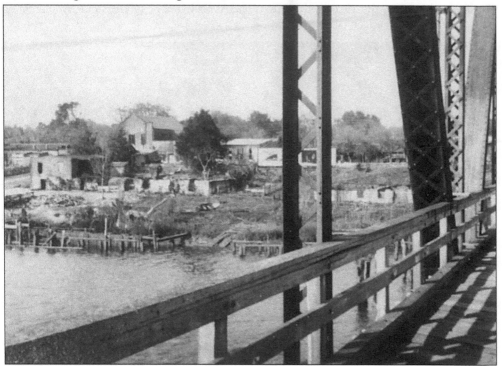

The tabby ruins along the Darien waterfront are visible in this *c.* 1930 photograph.

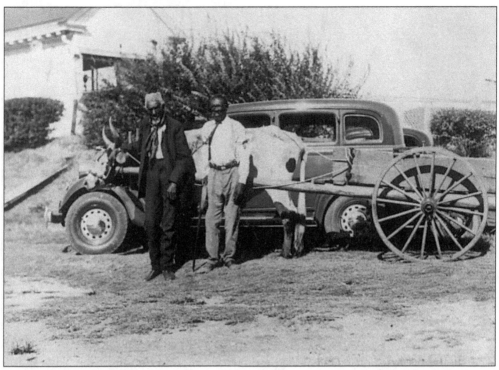

Liverpool Hazzard (left) is pictured *c.* 1935 with his ox cart on Butler's Island. Liverpool (1853–1938) was born a Butler slave. He lived in Darien for most of his life after emancipation. As an elderly man in the 1920s and 1930s, he made his living by telling stories of plantation days and African-American culture.

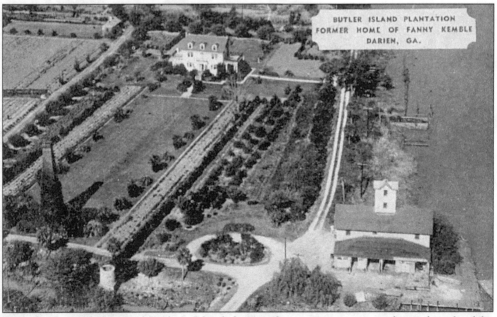

This aerial view of part of Butler's Island depicts the improvements made to the island by Colonel Huston in the 1930s. The old rice mill chimney is at left, partly covered by vines.

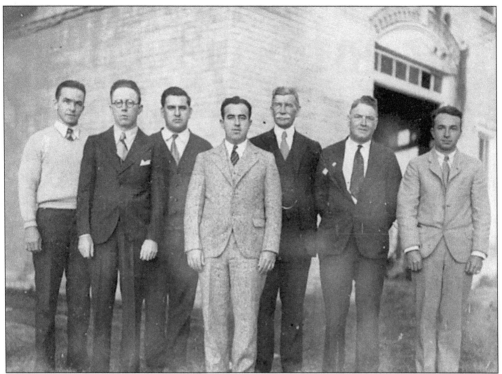

Pictured here are Darien and McIntosh County civic officials in a 1930 photograph taken at city hall. The men are, from left to right, Robert Young, Paul Varner, Legare Britt, Middleton Davis, John Clarke, Gene Cain, and K.S. Trowbridge.

The McIntosh County Courthouse, built in 1873, is shown here c. 1930. A fire in 1931 partially damaged the building. The restoration included refacing the building with an oyster-shell stucco. It was again refaced in 1980 when a new annex was built.

Darien Bi-centennial
CELEBRATION
April 16th, 1936, Darien, Ga.

Address by Governor Eugene Talmadge.
Address by Hon. J. Randolph Anderson.
Free Seafood Dinner.
Historical Pageant in Afternoon.

The Altamaha River is the thread of which the story of the old District of Darien is woven. In the beginning the mouth of the Altamaha and its environs were a source of international contention for two hundred years before the Battle of Bloody Marsh. Later the great River and its tributaries were, directly and indirectly, responsible for the many changes which have occurred in the history of the section. Therefore, the Spirit of the Altamaha will speak the theme of the Pageant, remaining upon the stage throughout the performance.

EPISODE I.

The Beginning. Enter the Spirit of the Altamaha and two Pages, Oconee and Ocmulgee. The Altamaha speaks.

Episode 1. Migration of the Creek Indians toward the rising sun. Indians enter, advancing East. Indian village scene. Enter Spanish soldiers and priests, scene typical of mission life; priests teaching Indians; soldiers on guard; French and English mentioned in dialogue.

Episode 2. Enter English raiding party. Battle in which Indions and Spaniards are driven from scene.

1716. Episode 3. Indians return and settle Huspaw town. Runner brings news of intended raid by Carolinians. Indians flee to St. Augustine.

1727. Episode 4. Fort King George.

EPOCH II.

1734. Episode 1. Oglethorpe visits ruins of old Fort King George selecting the site for the settlement of the Highlanders.

1736. Episode 2. Arrival of the Scotch Highlanders. Oglethorpe visits the Darien settlement. John Wesley visits John McLeod and attends the Presbyterian church. Scene in the village of Darien, featuring Highland songs and dances. Highland troops leave for siege of St. Augustine. Survivors of Battle of Moosa return, New embarkation arrives from Scotland. Oglethorpe calls for the Highland Company, and they embark for Frederica, to take part in the defense against the Spanish invasion. The Highland Company returns, triumphant, after the Battle of Bloody Marsh.

EPOCH III

1761. Episode 1. Marriage of Ann McIntosh, daughter of John McIntosh Mohr, to Robert Baillie, commander of Fort Barrington.

1760. Episode 2. Arrival of settlers from Williamsburg, S. C.

1776. Episode 3. Proclamation of Darien at beginning of the War of the Revolution. Departure of soldiers for the War.

EPOCH IV.

1793. Episode 1. McIntosh County laid out from Liberty.

1812. Episode 2. McIntosh County Volunteers depart for war.

In April 1936 Darien observed the 200th anniversary of its founding by Scottish Highlanders. The principal guest for the occasion was the governor of Georgia, Eugene Talmadge.

Program for the Day

April 16th, 1936

———

10:30 A. M. Firing of Governor's Salute by 118th Field Artillery.

Flag Raising Ceremony by Unknown Soldier Post No. 137 of the American Legion.

Invocation: Rev. L. B. Warren.

Address: "The Highland Settlement and the Development Along the Altamaha River," by Governor Eugene Talmadge.

Address: "The Colonial Period Prior to 1776," by J. Randolph Anderson.

1:00 P. M. Free Shore Dinner.

3:00 P. M. "The Pageant of Darien," enacted at Lower Bluff, the site of the landing of the Highlanders.

— 9 —

The commemorative program of Darien's 200th anniversary observance reflects the considerable pride the old community takes in celebrating its beginnings.

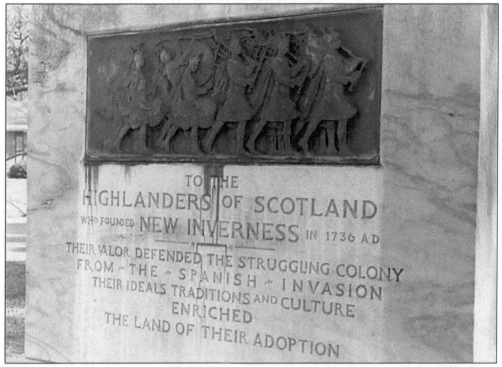

Sculptor Tait McKenzie created the bronze frieze of Scottish Highlander bagpipers and drummers for this marble monument, which was dedicated in May 1936 in Darien.

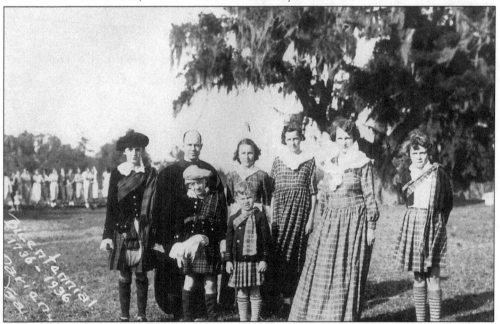

The 200th anniversary observance was highlighted by the "Pageant of Darien," written and produced by McIntosh County historian Bessie Mary Lewis. The cast of the pageant was comprised primarily of local residents, many of whom were descendants of the original Scottish settlers of Darien.

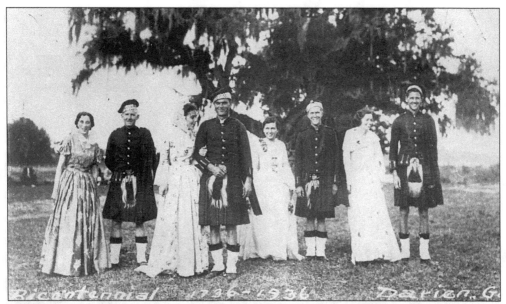

Shown are more cast members of the 1936 "Pageant of Darien." This event was one of many contributions to the interpretation of local history made over the years by Bessie Lewis (1892–1983.) She also edited the *McIntosh County News* in the 1940s. In the 1920s and 1930s, Miss Lewis played a leading role in determining the exact site and history of Fort King George, which was developed near the future town of Darien in 1721 as the first English foothold in Georgia.

The Altamaha Inn on U.S. 17 in Darien was opened in 1929 and was operated for many years by Mr. and Mrs. Robert S. Townsend.

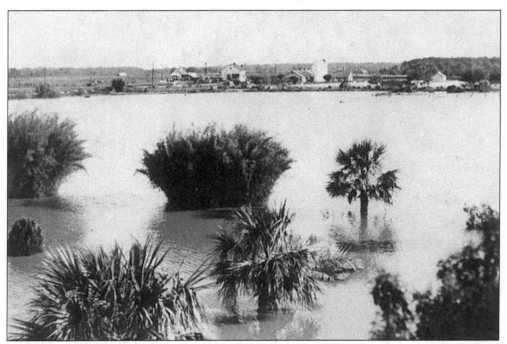

The Altamaha River was subject to occasional periods of flooding, particularly in the spring and summer. These floodings were known as "freshets." Pictured here are the results of a freshet on Butler's Island in 1936.

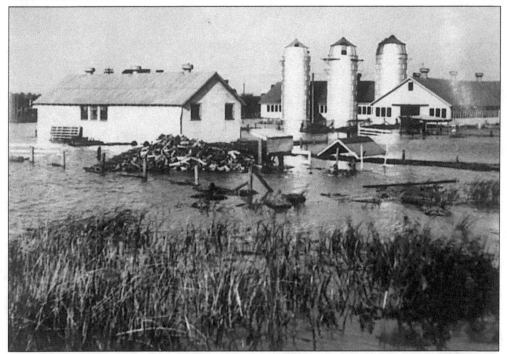

The freshet of 1936 was one of the worst to hit the lower part of McIntosh County in the first half of the 20th century. Shown in this photograph are some of the Butler's Island dairy buildings partially underwater.

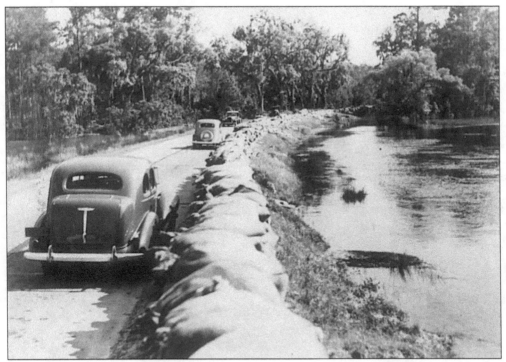

The Atlantic Coastal Highway on Champneys Island during the 1936 flood reveals that sandbags have been utilized to stem the rising water. These floods were the bane of the rice planters who cultivated the Altamaha bottom lands throughout the 19th century.

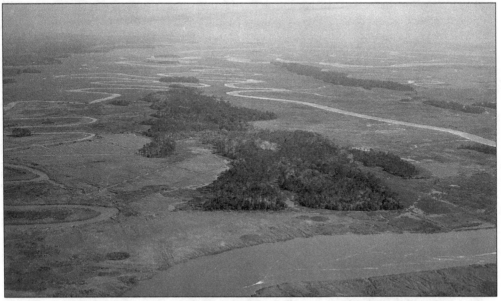

An aerial photograph from the 1940s reveals the tidal rivers, creeks, and salt marshes just east of Darien. At the bottom of the picture is the "Long Reach" of the Darien River. The high ground in the center of the picture is Black Island, owned at the time by Paul Varner. Above Black Island is Hird Island, with Mayhall Creek flowing between them. Black Island Creek is to the left.

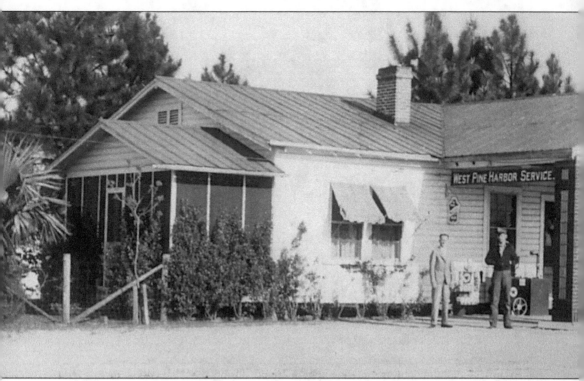

At the junction of the Atlantic Coastal Highway and Pine Harbor (Mallow) Road, about 14 miles north of Darien, was this store and gasoline service station, which operated in the 1930s and 1940s. During this period, the naval stores and forestry industry was preeminent around the Townsend, Eulonia, and Pine Harbor sections of McIntosh County. Elisha M. Thorpe managed the McIntosh Naval Stores Company at Townsend. In the 1930s and '40s, the Pine Harbor

The Sapelo River and the waterfront bluff at Pine Harbor are shown here in the 1930s. Pine Harbor was begun in 1912 when the Fairhope Land Company, comprised of a group of investors from Akron, OH, bought land and developed a planned township. Lots were surveyed and sold according to a 1913 plat.

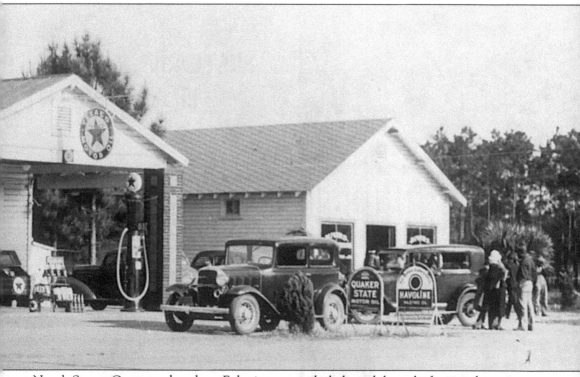

Naval Stores Company based at Eulonia managed slash and long leaf pine plantations comprising 28,000 acres for the production of rosin and turpentine. Other large operations of this type were the Cox Naval Stores Company at Cox and the Warsaw Lumber Company at Warsaw.

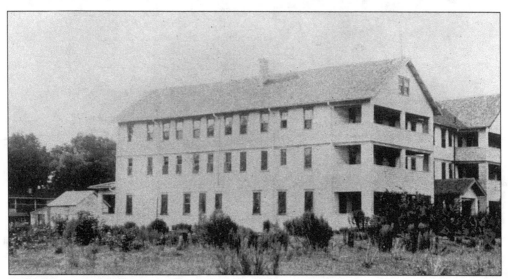

This three-story hotel was built on the waterfront at Pine Harbor. The Georgia Coast & Piedmont Railroad built a spur track to Pine Harbor from Eulonia. The hotel was torn down in 1930 as it was unprofitable. Pine Harbor became a quiet residential settlement of local and seasonal residents.

HISTORIC 2,500 - ACR
ISLAND PLANTA

Income-Producing Truck Farm . . . 11-Room Reside

On two large islands off the Georgia Coast, connected to the mainland by U.S. Route 17, is the fabled Butler Island Plantation. Presently a flourishing truck farm, the plantation's history dates from 1790 when it was established by Revolutionary War hero, Major Pierce Butler. It was to Butler Island Plantation that the fabulous English actress, Fanny Kemble, came as the bride of Pierce Mease Butler two decades before the Civil War.

The fertile delta tract near the mouth of the Altamah River, rich in alluvial soil, was a rice plantation until 1910. In 1927 it was converted to a dairy farm and the subsequent development of fine herds has proved it to be as suitable for pastures as for truck farming.

Today, under modern agricultural methods, it produces bumper truck crops. Its rich soil, carefully and scientifically cultivated under the direction of its present manager, a graduate of Texas A. & M., produced 25,000 crates of premium iceberg lettuce in the spring of 1953. Beans, cabbage and cauliflower are marketed in the fall. The farm operation is complemented by large packing and storage buildings and there are ample living quarters for farm help. Complete farm and packing equipment, including trucks and tractors, is included in the offering price.

The residence, a beautiful Colonial house of 11 rooms with 6 bedrooms and 3½ baths, was built in 1927 of top quality materials and would be difficult to reproduce today. Modernized in 1949, it is luxuriously appointed throughout and contains every up-to-the-minute facility for comfort and convenience.

In typical
rooms are o
A graceful
which conta
and large co
fireplaces in
many-windo
ment playro
tinguishes m
are numerou
screened din
room, and al
open to sund

Terraced l
and bamboo
is set about
brick chimne
stands, and is
symbolizing

Delightfu
tion, this exte
from Darien,
facilities of I
ble to the in
Saint Simon's

With its
residence, pr
location, But
appeal. As t
man, it offe
country livin;
ing property
would find f
rich acreage.
could be com
no great expe
a hunting a
private or co
abound in the
facilities for b

View from Residence

Living Room

Dining Room

m Buildings

shion, its spacious
nd a center hall.
matizes the hall,
ous powder room
here are beautiful
ing room, in the
n and in the base-
all paneling dis-
rooms and there
eties of decor. A
djoins the dining
nd floor bedrooms

ed with palm trees
e residence which
the highway. The
ginal rice mill still
nt on the grounds
on's history.
 by its island loca-
ation is just 1 mile
from the excellent
nd readily accessi-
ts, Sea Island and

d history, superb
nd and enviable
lantation has wide
f a retired gentle-
mate in gracious
than self-support-
prising purchaser
s of exploiting its
on as a truck farm
dairy farming. At
ld be converted to
lodge either for
use. Game birds
there are excellent
age.

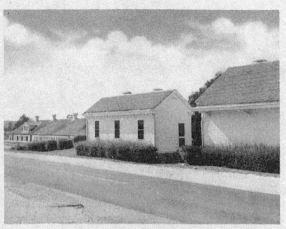

Office Building

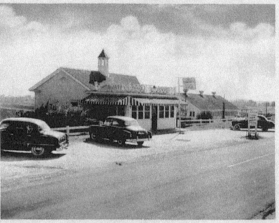

Dairy Bar Restaurant

Packing Shed

In 1953, Butler's and Champneys Islands were offered for sale by owner Richard J. Reynolds Jr. He had acquired the properties just after World War II from the estate of T.L. Huston. The advertised price in this sales brochure was $79,500, including the three-story residence, dairy barn (then used as a vegetable packing shed), and other farm facilities. Butler's Island comprised 1,700 acres and Champneys was 800 acres. Over 25,000 crates of Great Lakes-variety iceberg lettuce were shipped from the truck farm operation in 1953. Reynolds modernized the 11-room residence in 1949.

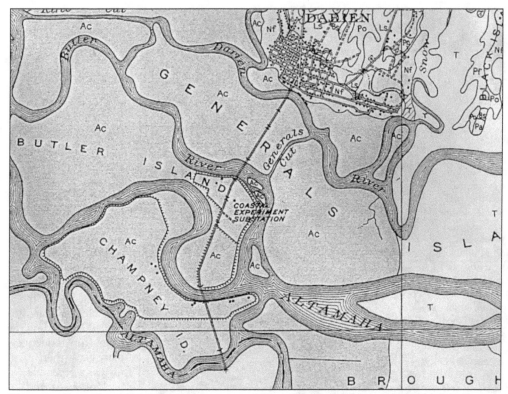

This map from the 1929 U.S. Department of Agriculture soil survey of McIntosh County delineates Darien and the Altamaha delta islands of Generals, Butler's, and Champneys. Note the coastal highway built over the track bed of the Georgia Coast & Piedmont Railroad, as well as Generals Cut.

The Oglethorpe Inn tourist lodge in Darien was operated by the Cain family in the 1930s and 1940s. This residence was located on east First Street, one block west of U.S. 17.

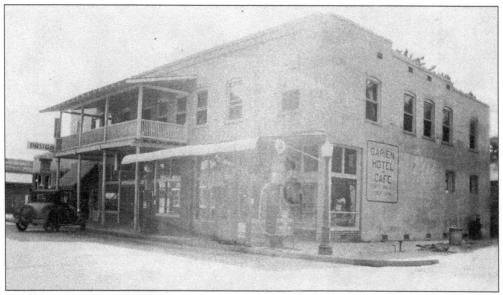

This view from the early 1930s depicts the Darien Hotel and Café, located on Walton Street (U.S. 17) a block from the river front. This building was later a general store operated by Mr. and Mrs. S.G. Patelidas in the 1950s and 1960s. At far left, on the corner of Walton and Broad streets, is a portion of the general store opened c. 1895 by Meyer Bluestein, forerunner to the Bluestein family's grocery business of three generations.

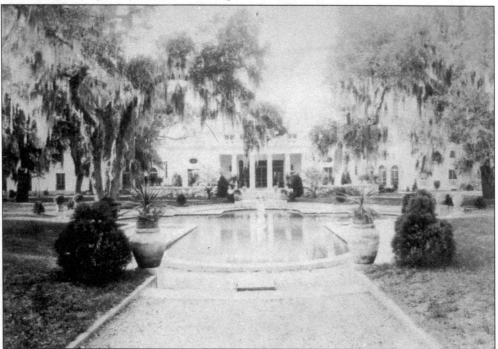

Sapelo is McIntosh County's barrier island. In the 1920s, Detroit automotive executive Howard E. Coffin restored South End Mansion, shown above. Tobacco heir Richard J. Reynolds Jr., of Winston-Salem, NC, bought Sapelo Island in 1934. Although only a part-time resident, R.J. Reynolds was McIntosh County's most affluent citizen until his death in 1964.

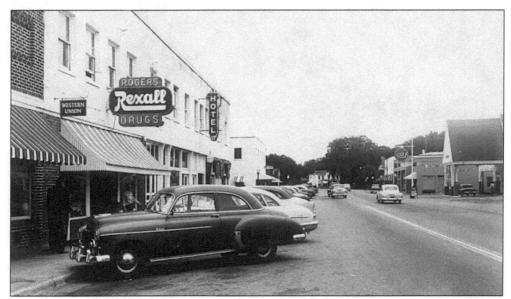

This is Darien's business district on Walton Street (U.S. 17) in the mid-1950s. Businesses, from left to right, are William Fisher Dry Goods, Rogers Drug Store, Darien Hotel, and the Darien Post Office. Across the street are Dan White's law office, Archie Davis's Darien Grill, and E.G. Wilkins' service station and garage. In the center at the end of the street is the county jail.

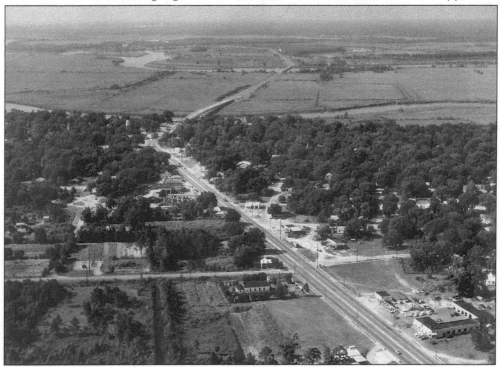

Darien from the air in 1960 shows a quiet shrimping town of 1,400 residents spread out along both sides of U.S. 17, which is seen curving through the Altamaha delta south of town (the top of the picture). The business district is clustered near the bridge. Pack Chevrolet (right) and the Catholic church (left) are shown near the bottom.

INDEX

Visit us at
arcadiapublishing.com